DESERT WONDERLAND

A Serene Coloring Retreat

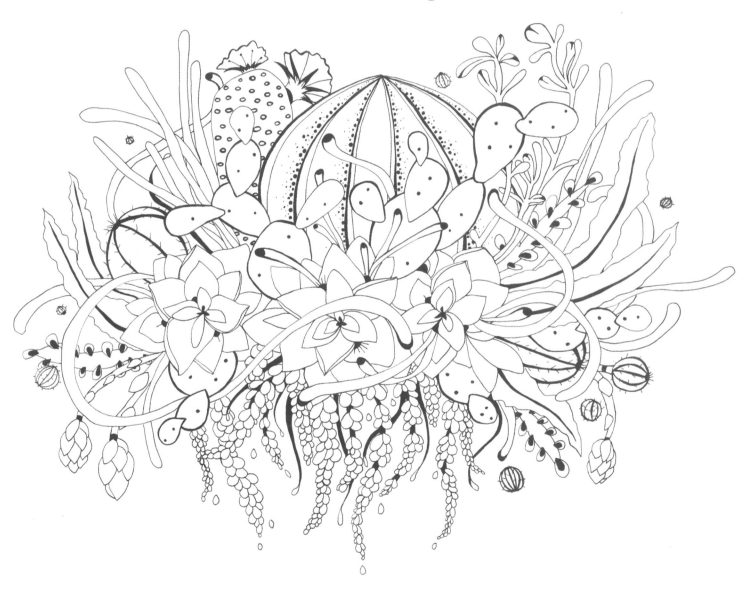

RACHEL REINERT

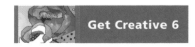
Get Creative 6

INTRODUCTION

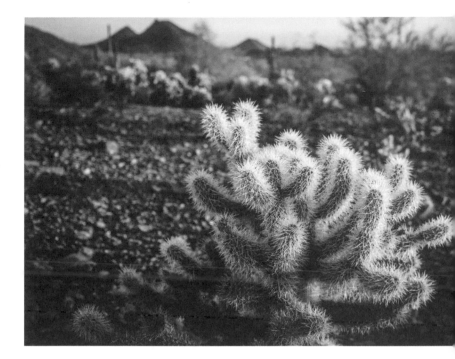

To me, the desert is a place of mystery and intrigue. In a setting that seems uninhabited and desolate, there is an oasis of life if you look closely. The desert's strange shapes and forms grow wild and free amid harsh conditions; an entire ecosystem flourishes against the odds. I am attracted to the beauty of this environment, where life perseveres and conquers despite adversity.

Desert Wonderland, my follow up book to *Botanical Wonderland*, is an exploration of desert forms aimed to capture the world of these playful plants thriving in unique compositions. After being inspired by my travels around Australia, where *Botanical Wonderland* was dreamt up, I returned home to rediscover the USA. I visited the vast Sonoran Desert and fell in love with the landscape. Being the hottest desert in North America, it is also the only place in the world where the saguaro cactus grows wild. The endemic flora and fauna found in this dry landscape have given me endless inspiration for these drawings, and I can't wait for these pages to be filled with color!

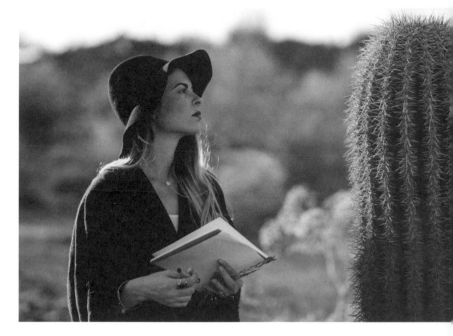

I chose to include various female portraits, which I also see as a representation of beauty through confidence in an unlikely environment. I hope to inspire and remind all people of our innate strength as individuals, and to care for others and the natural world.

Just as desert plants and forms are wild and free, I encourage you to be bold with your coloring! Beyond colored pencils, try using gel pens or tearing out the perforated pages and experimenting with watercolor pencils. The desert landscape is a rainbow of vibrant hues, so try contrasting shades or unique combinations to fill the pages with color.

Bring life into a black and white world.

—RACHEL REINERT

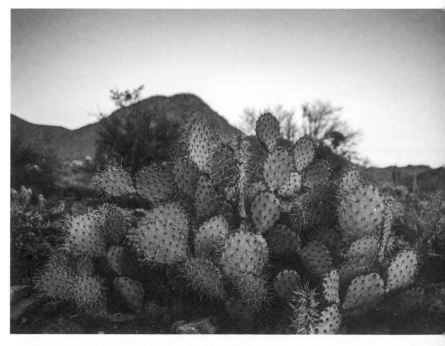

ABOUT THE AUTHOR

I've had an inherent need to create since I was young. It is what drives me every day, and I'm continually investigating my creative process. Whether illustrating with pen and ink, painting large abstract canvases, or designing prints on objects, making art is my way of life. I've traveled to 18 countries with my husband, and I glean inspiration from each place we visit. We are both passionate creatives with a heart for telling stories and capturing moments. I currently work from my home in San Diego, California, and I dream of traveling even more. www.rachelreinert.com

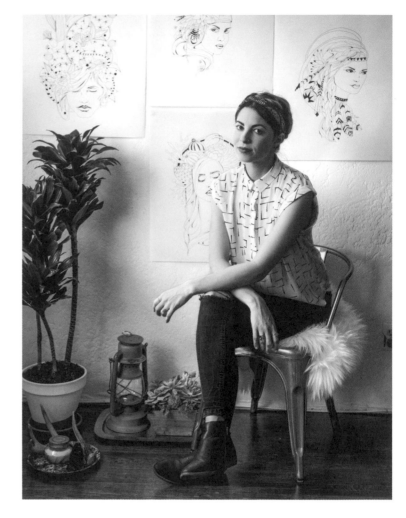

Get Creative 6

An imprint of Mixed Media Resources

19 West 21st Street, Suite 601, New York, NY 10010

sixthandspringbooks.com

ISBN: 978-1-942021-54-4

Manufactured in China

9 10

First Edition

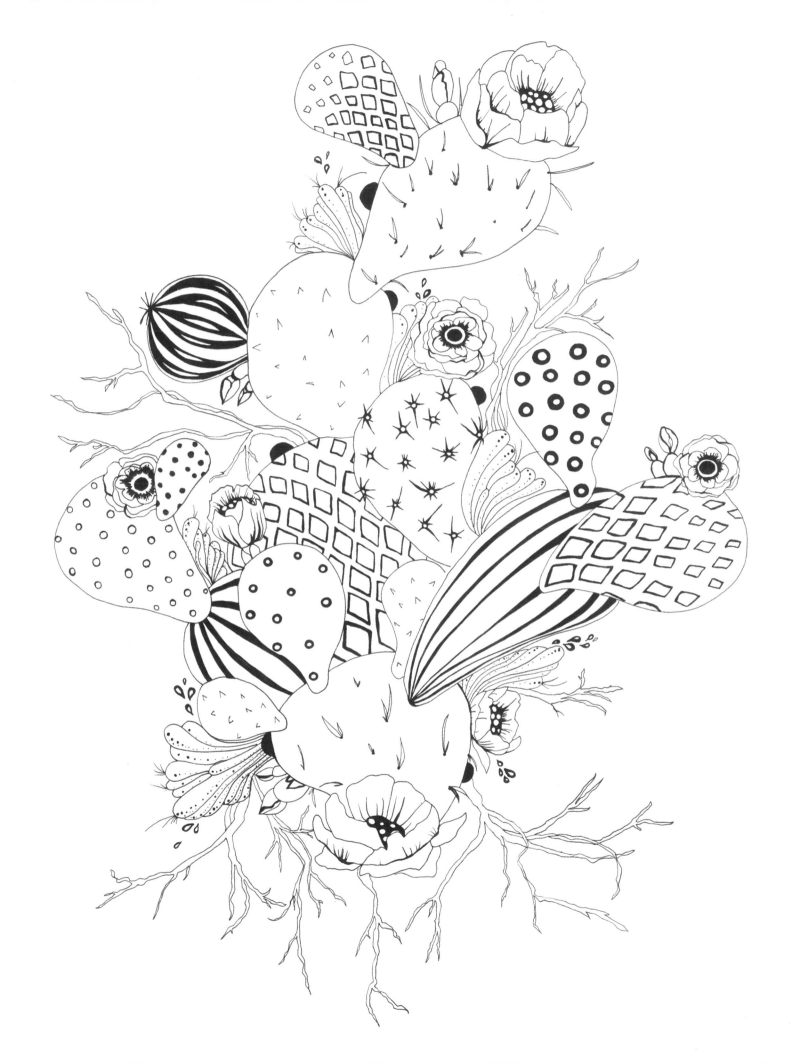

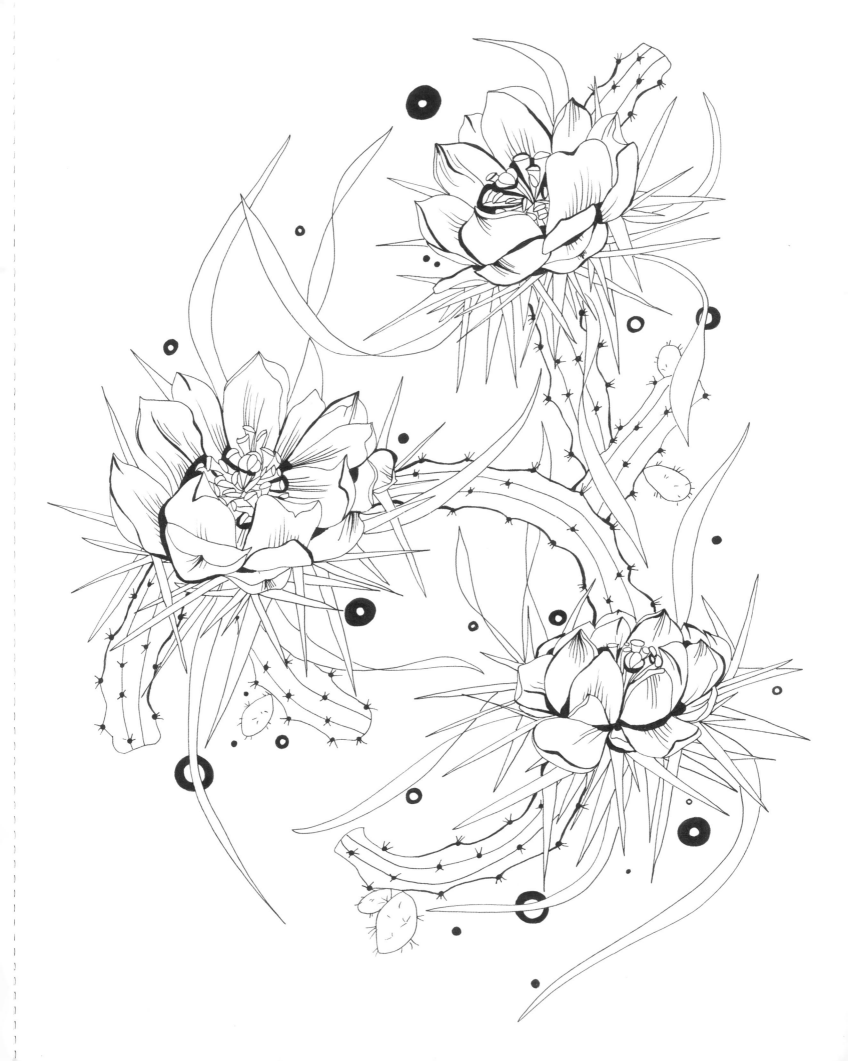

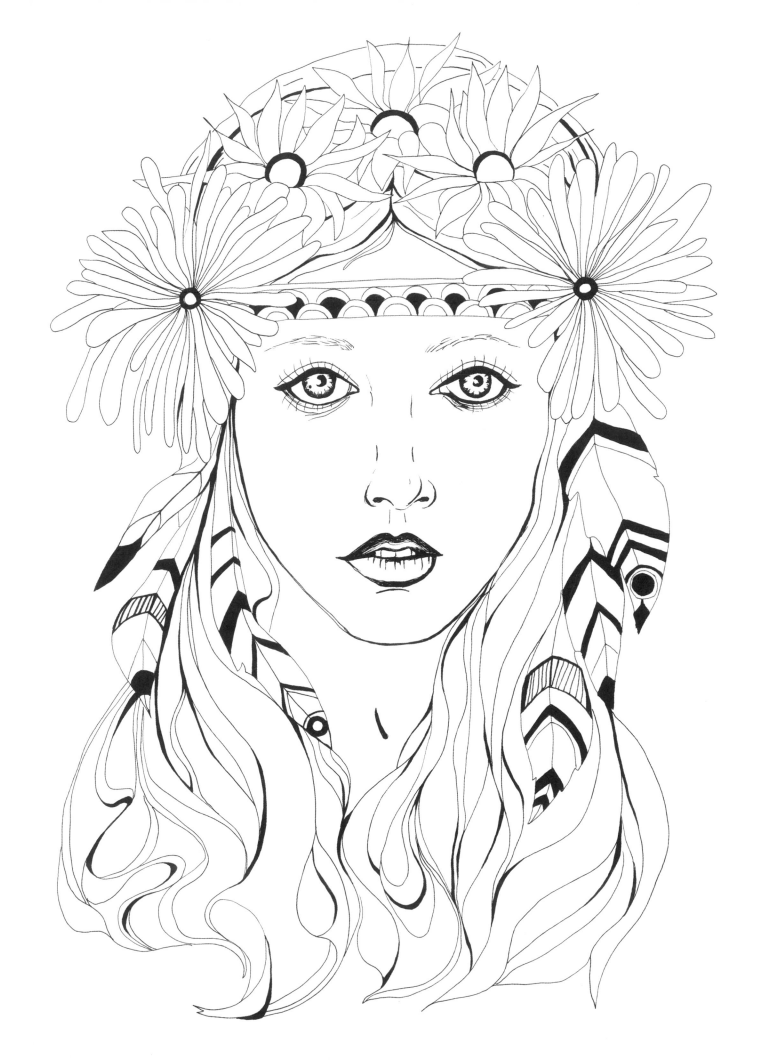

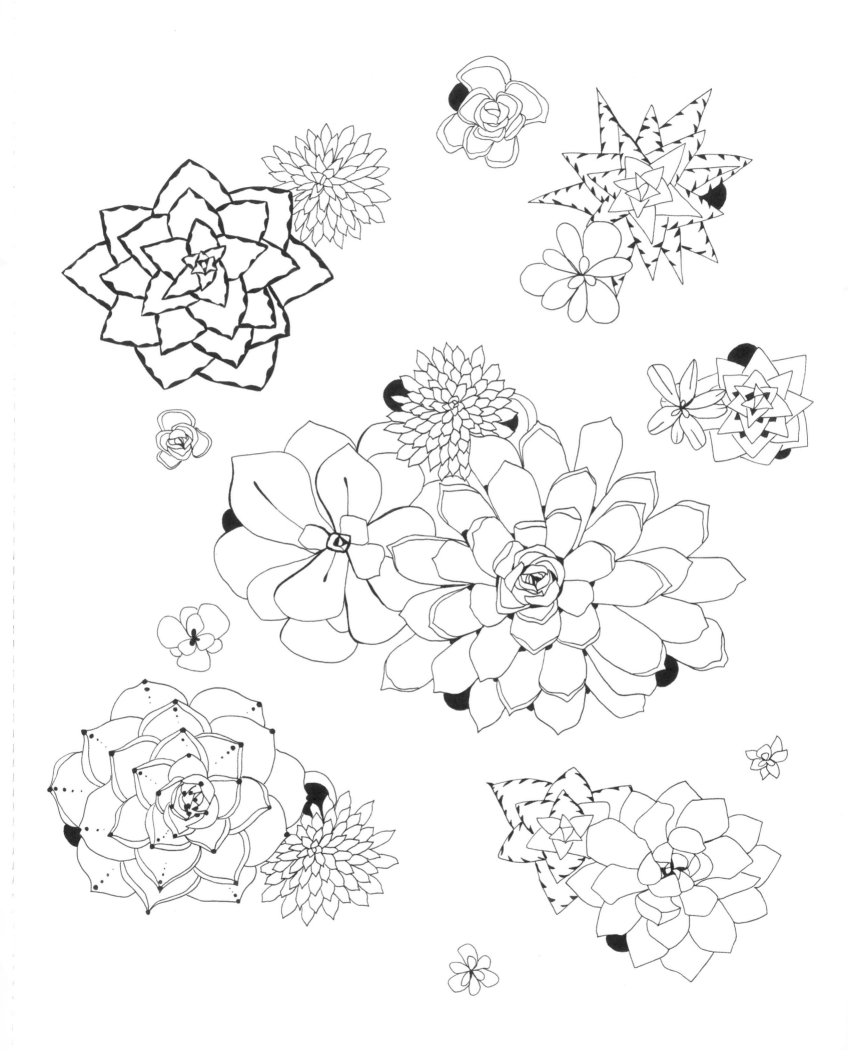

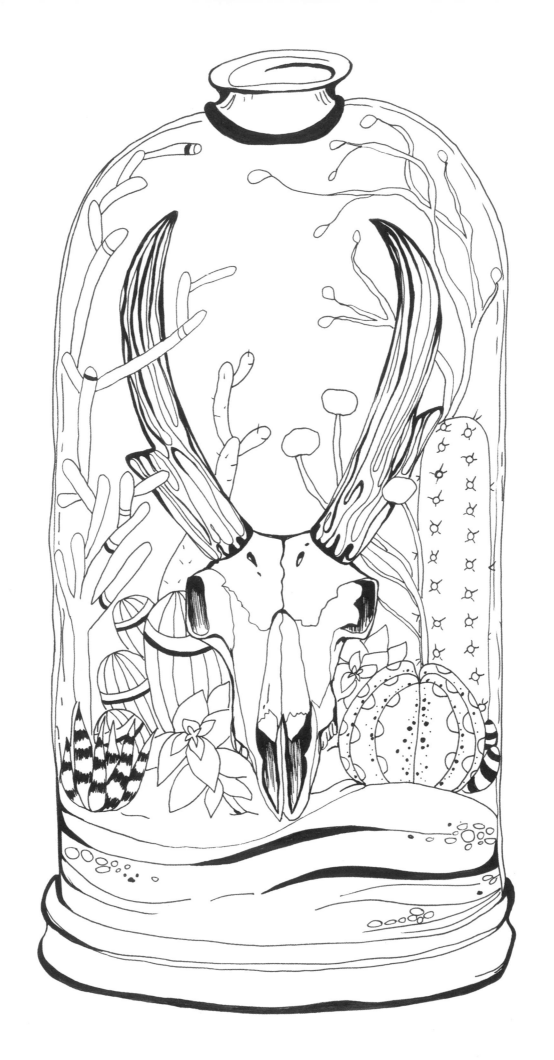

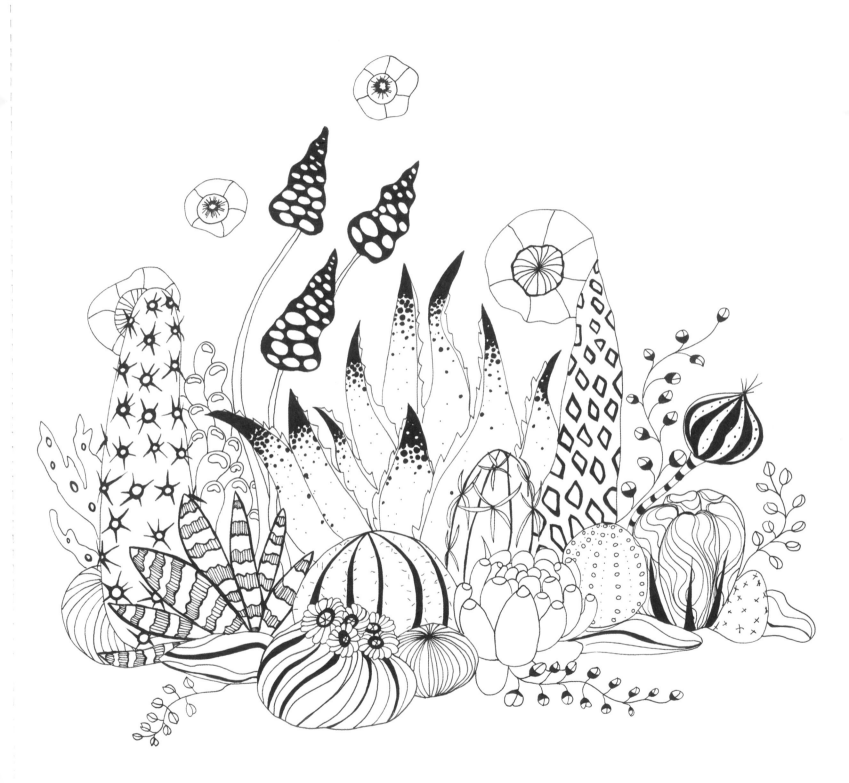

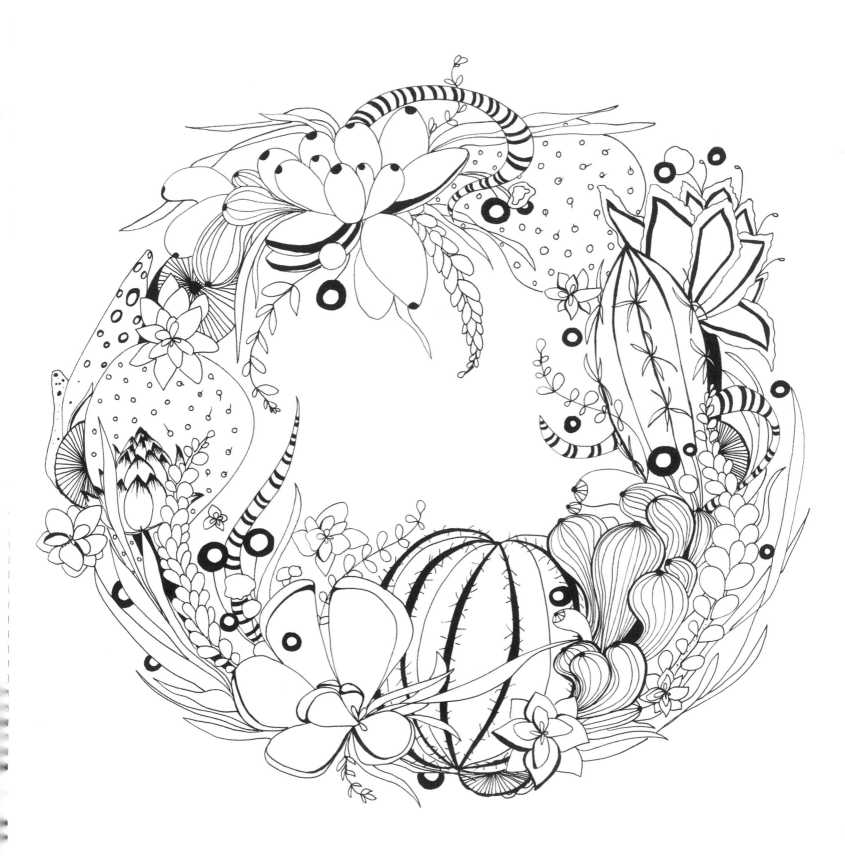

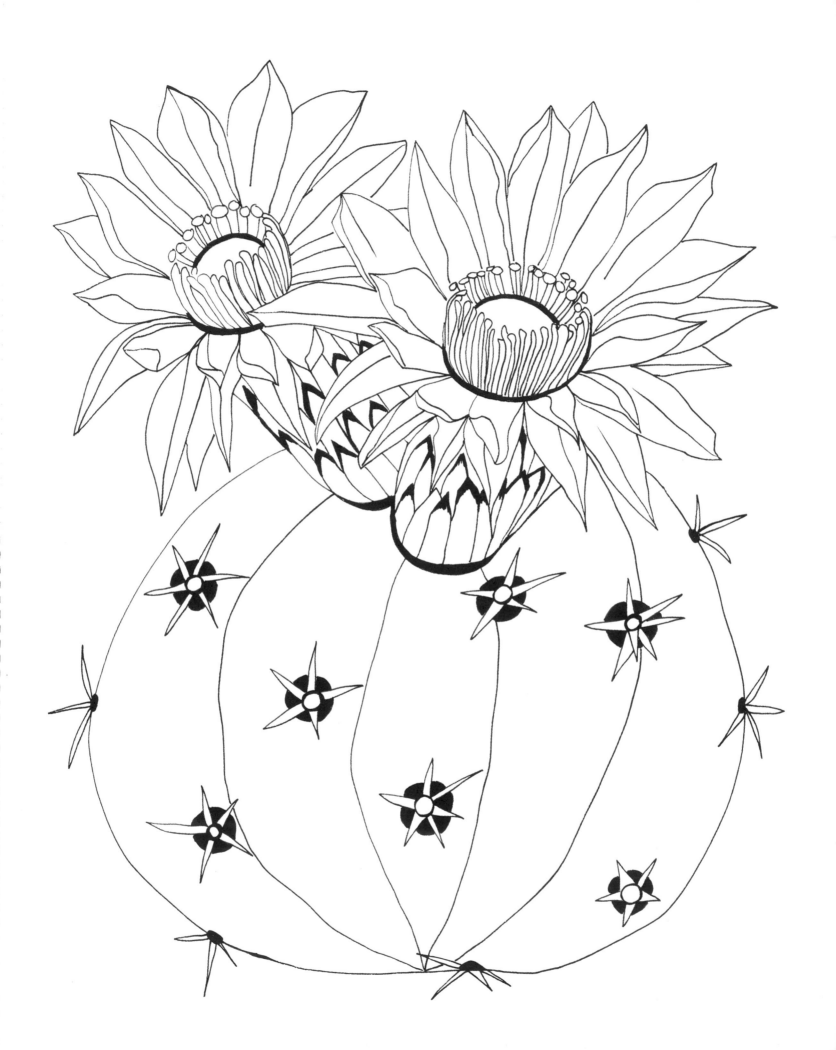

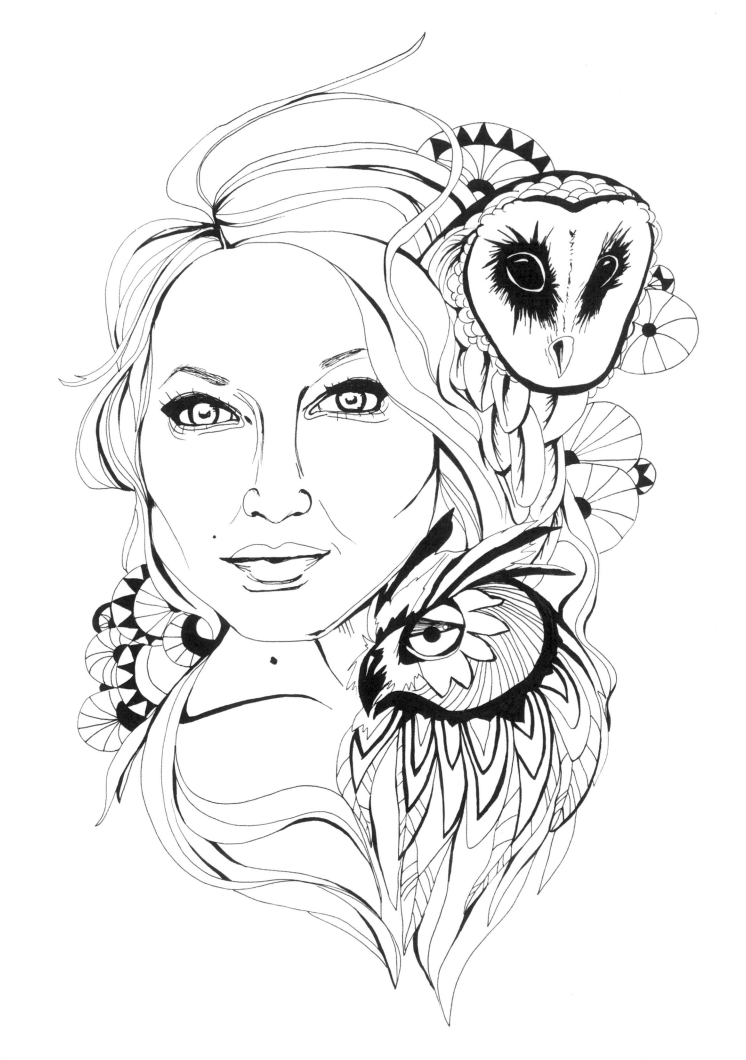

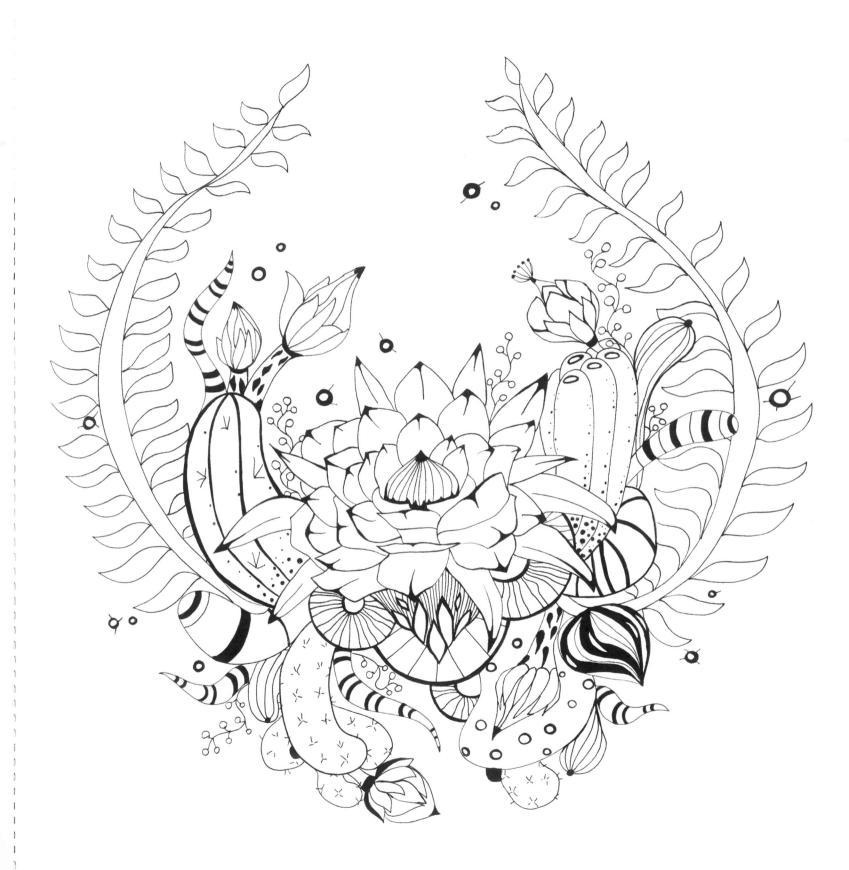

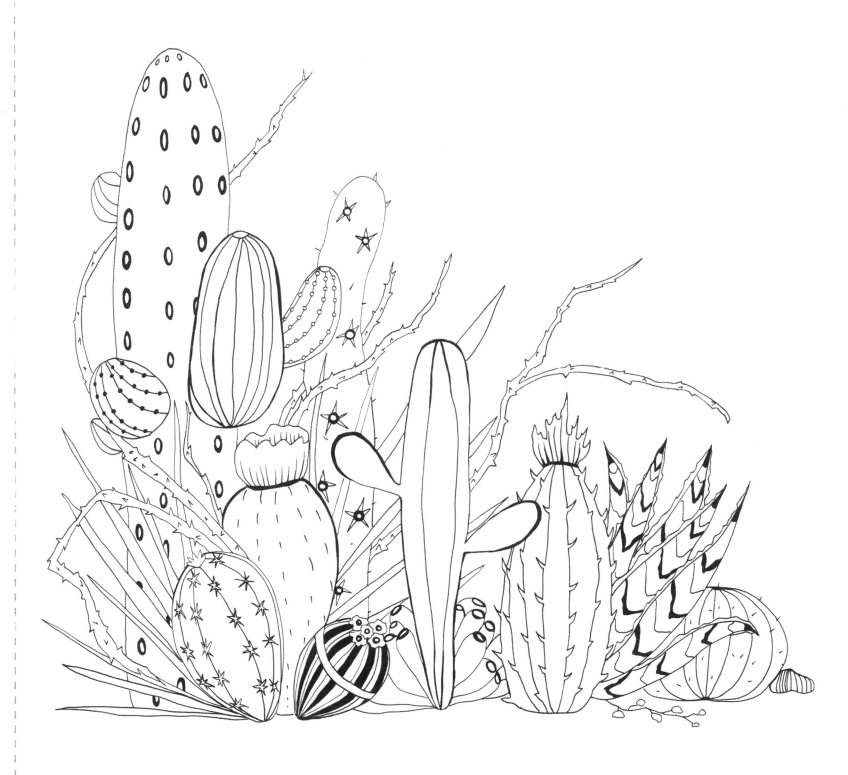

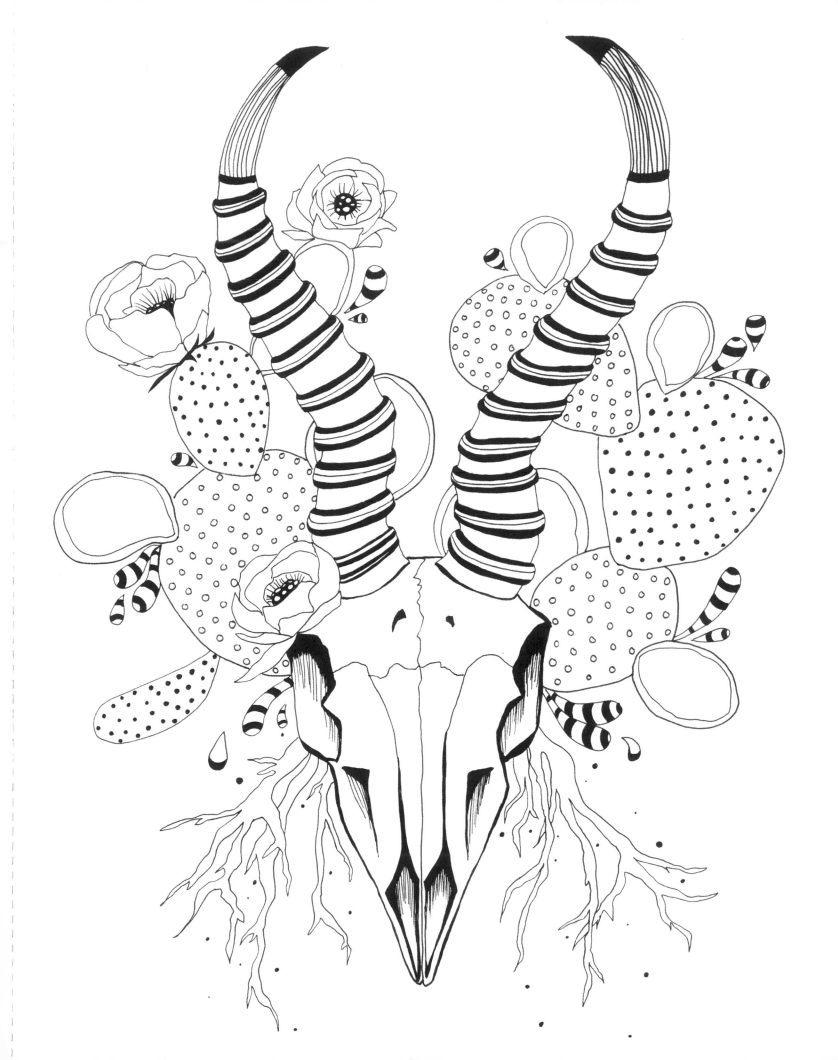

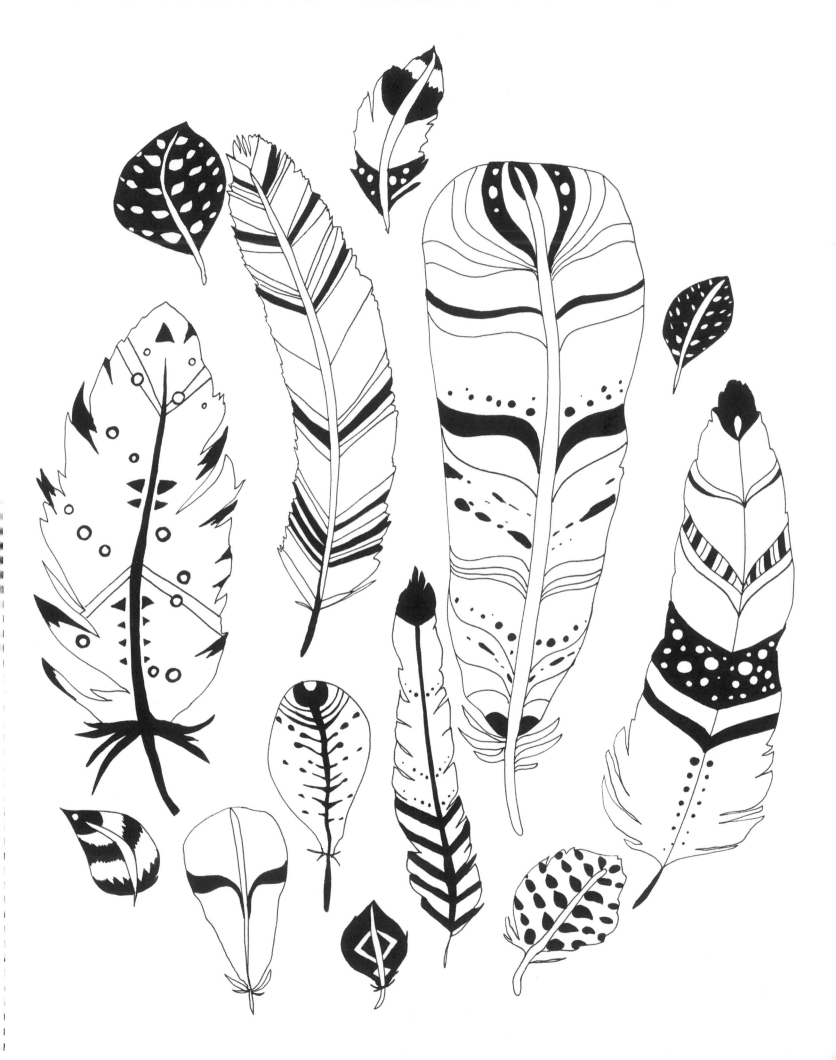

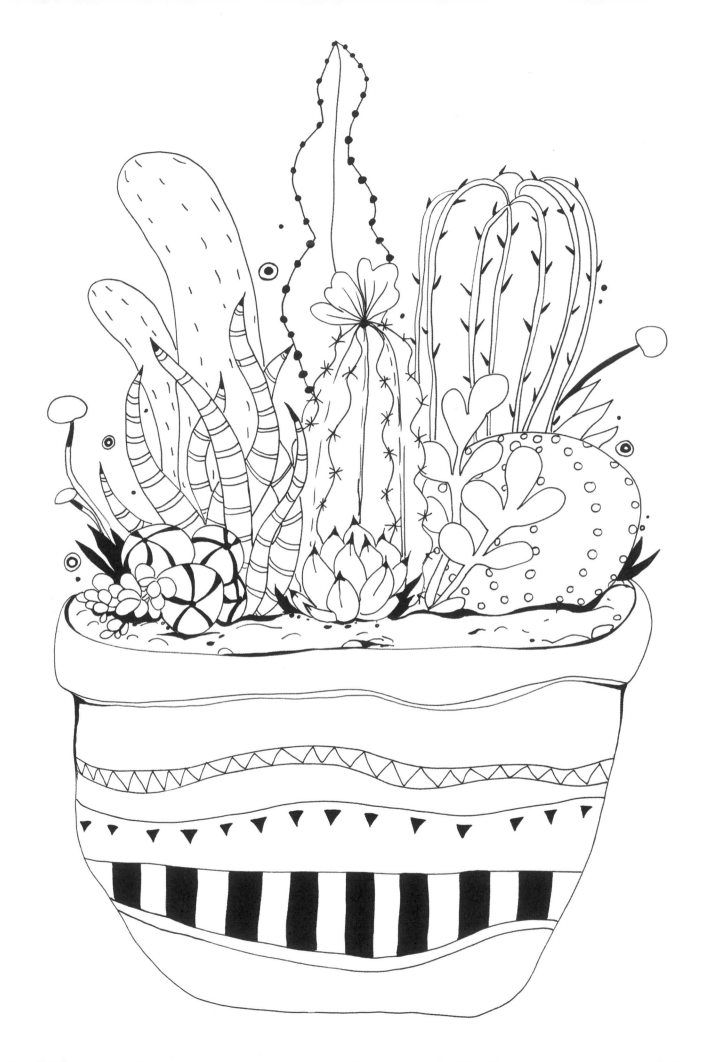

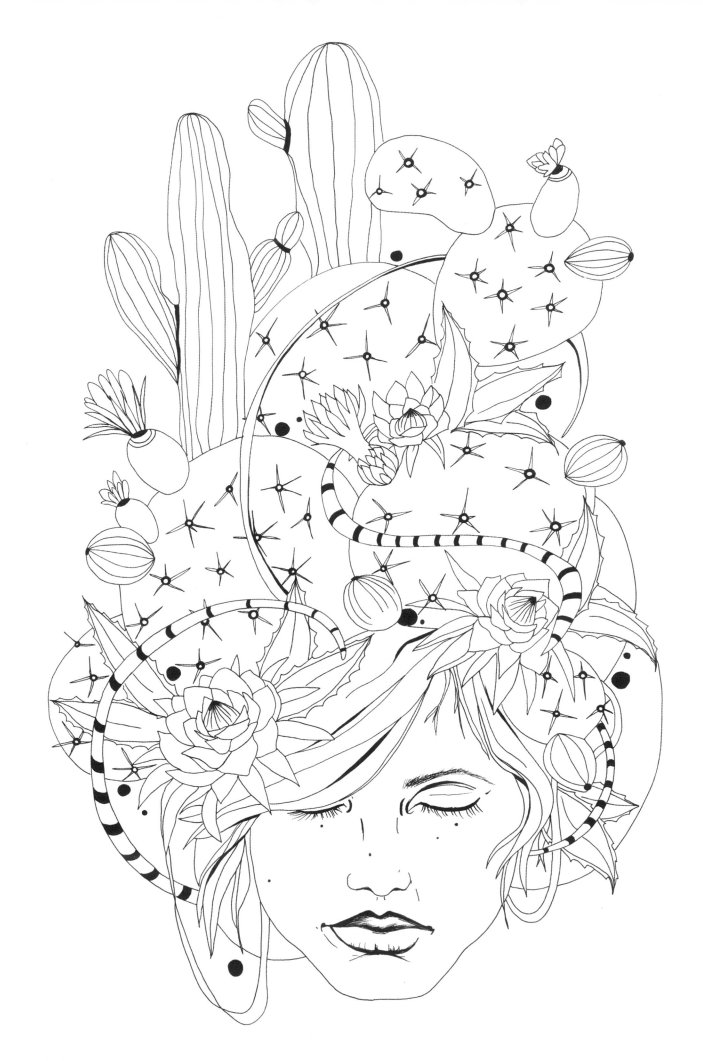

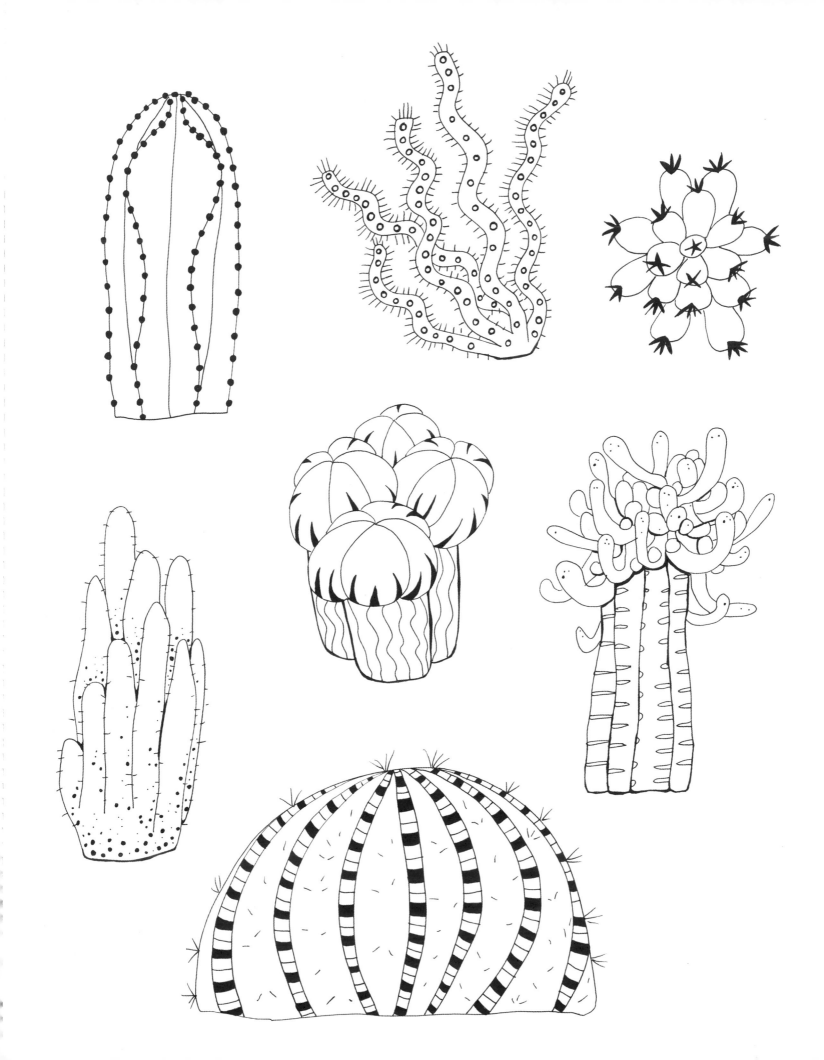

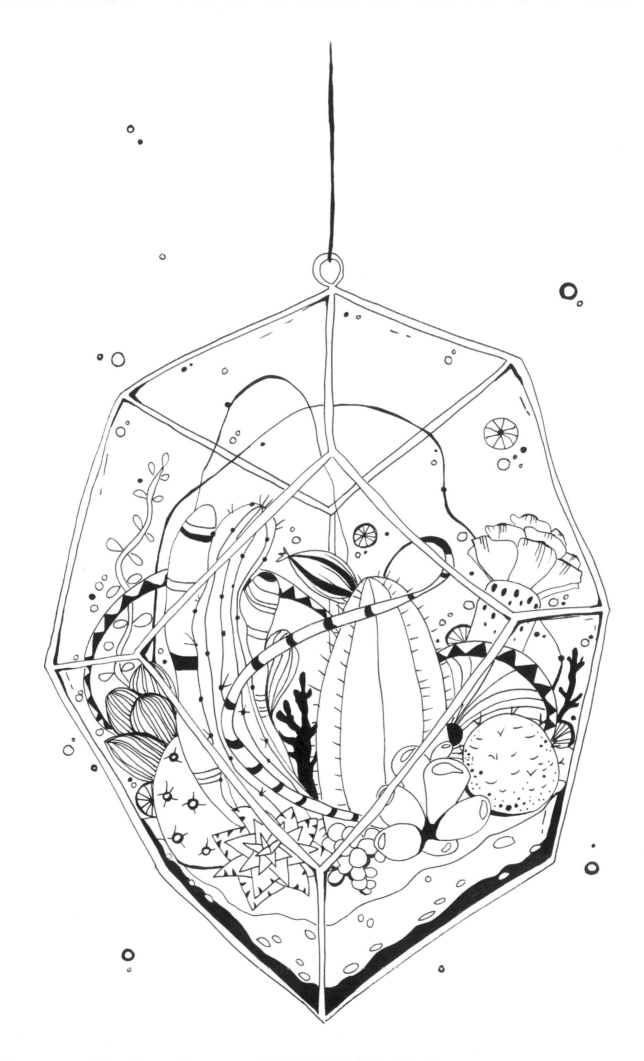

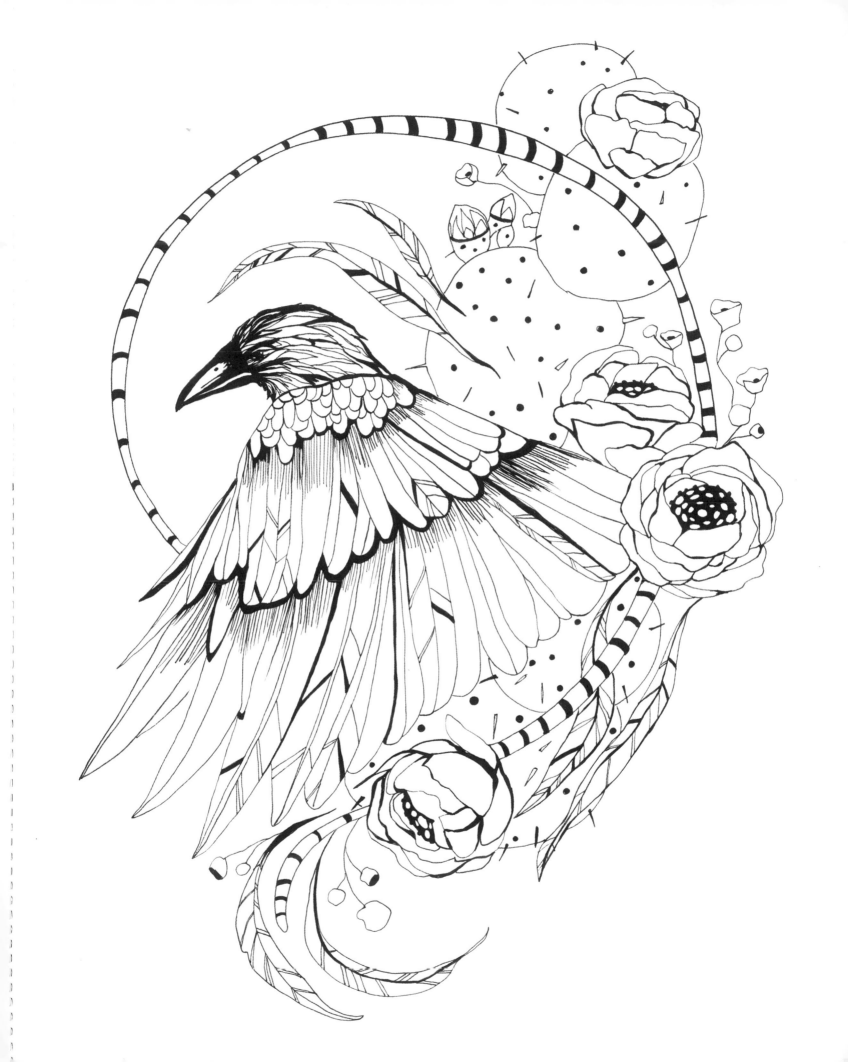

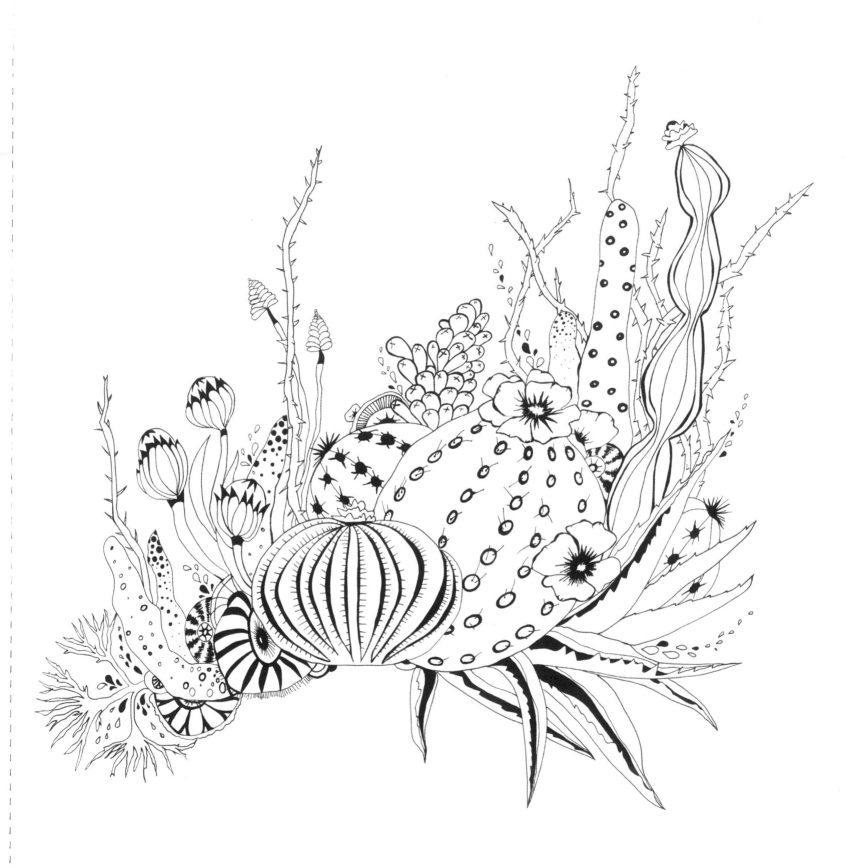

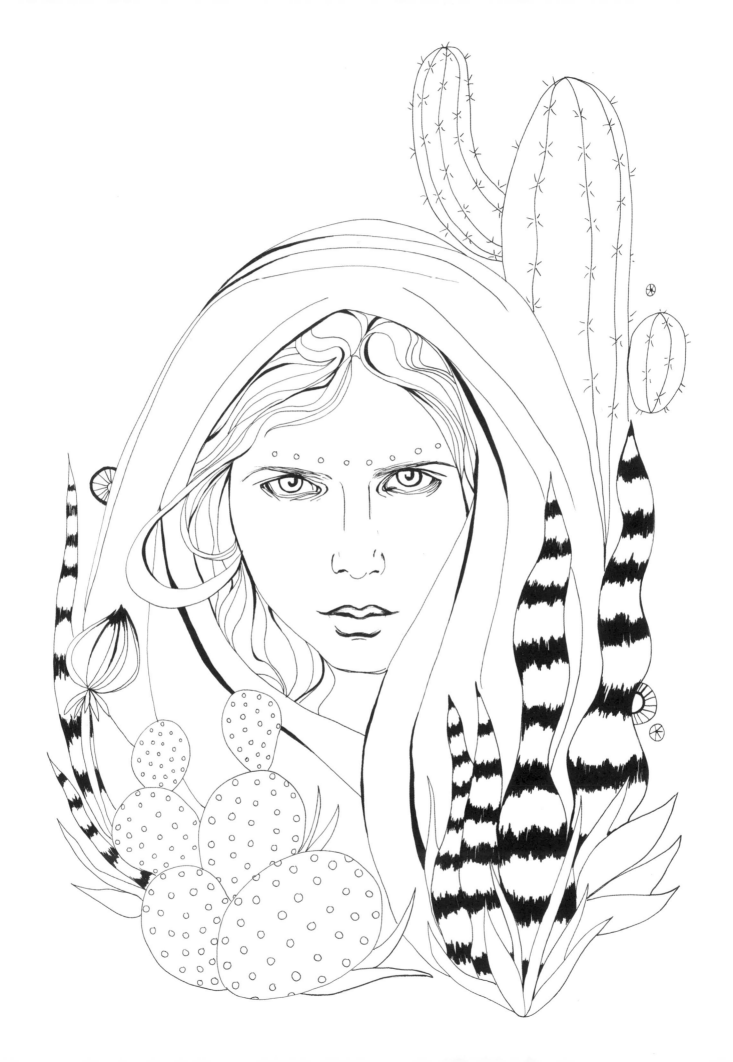

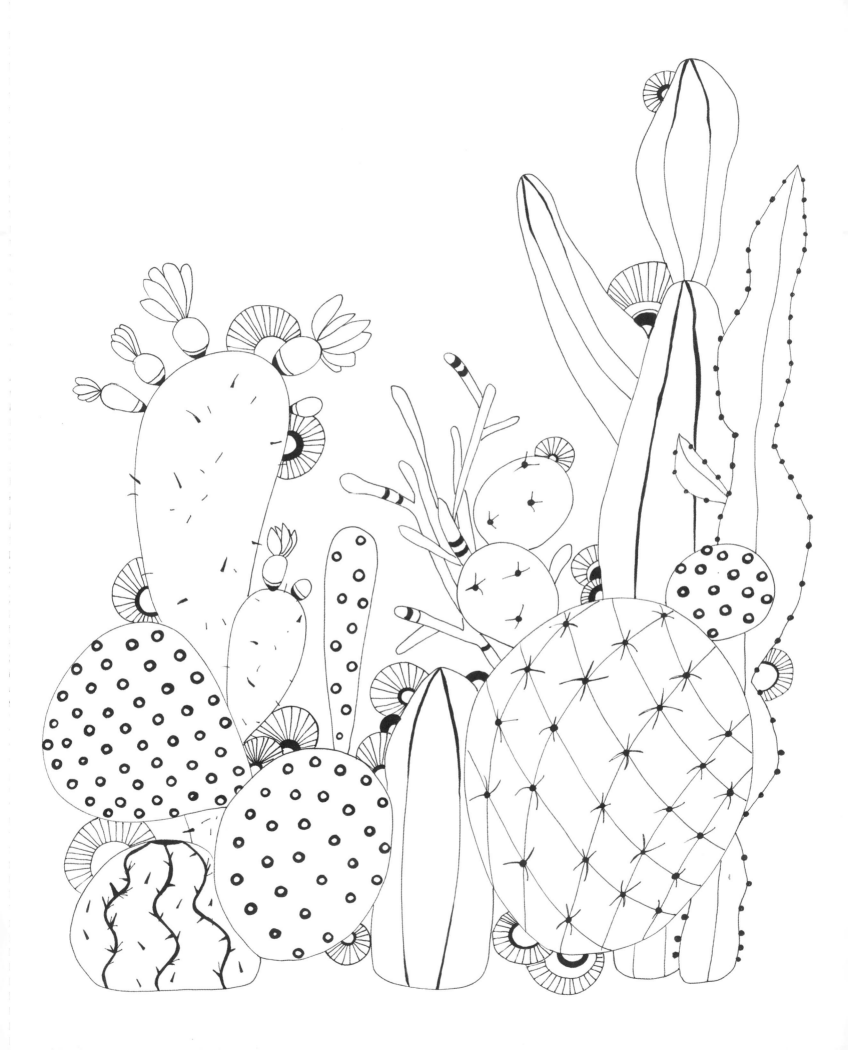

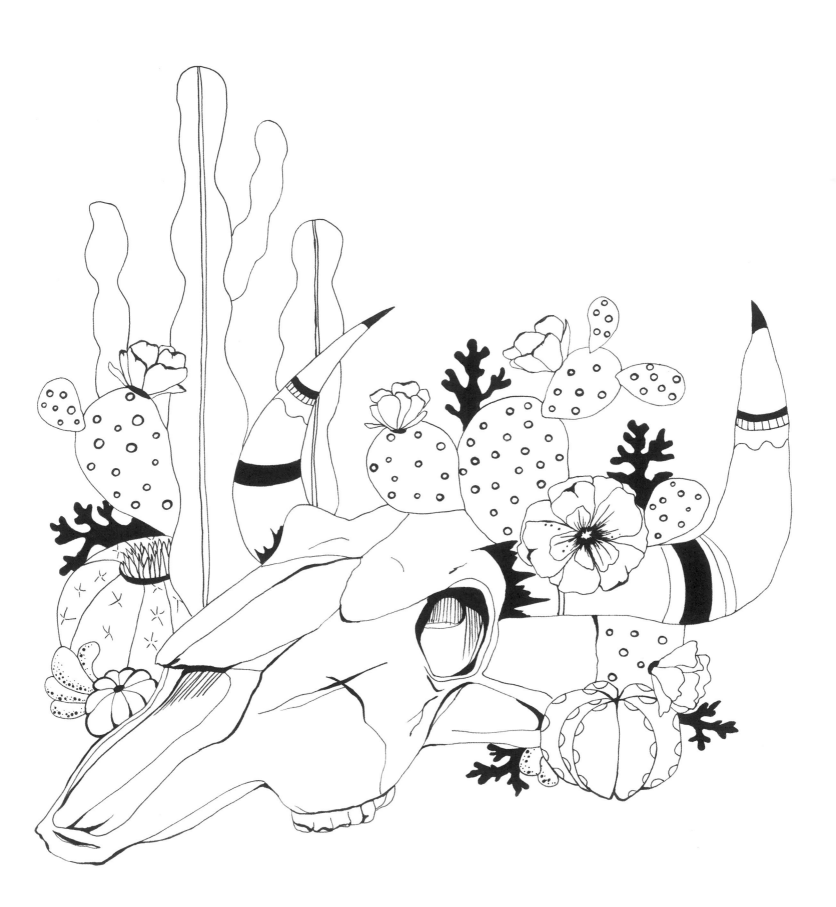

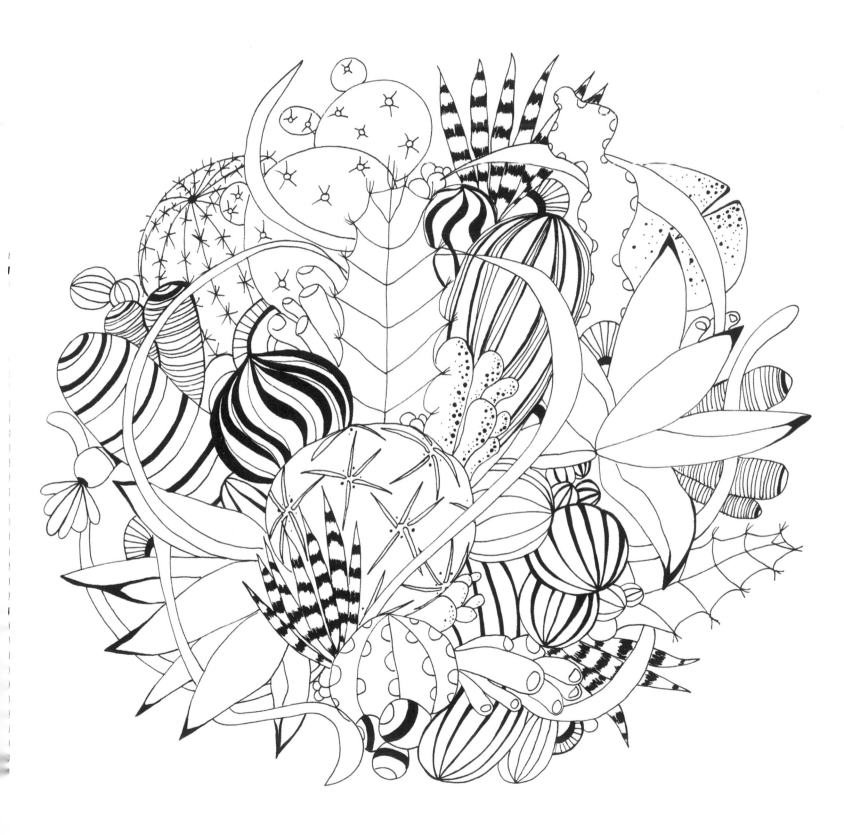

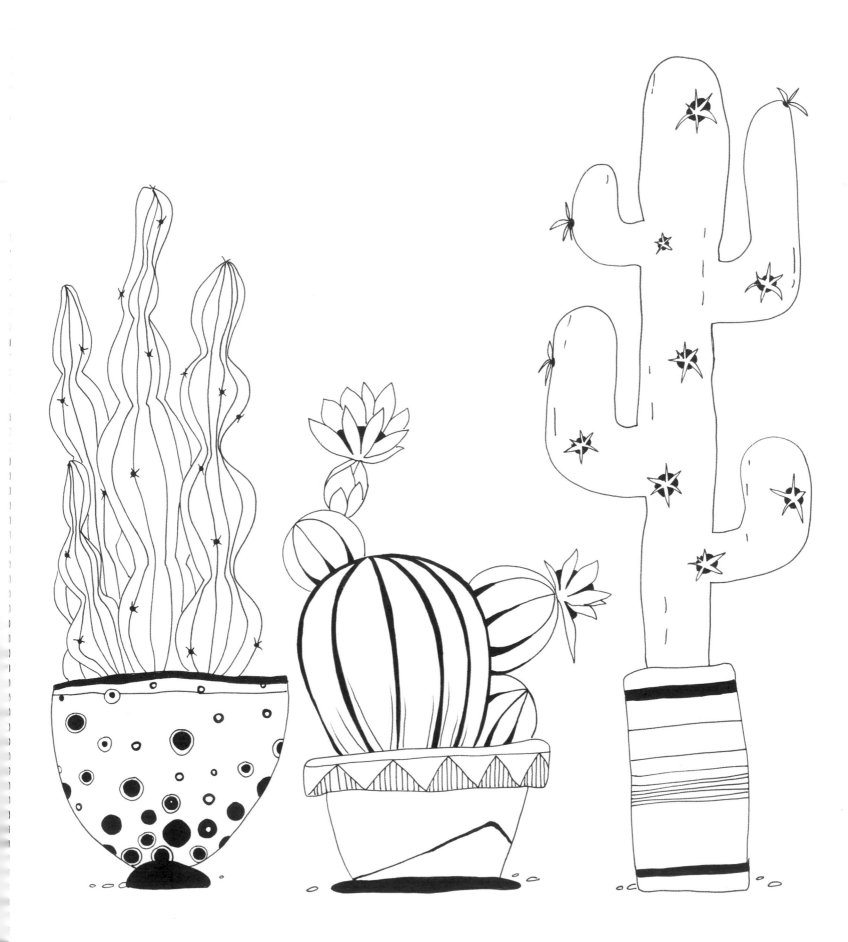

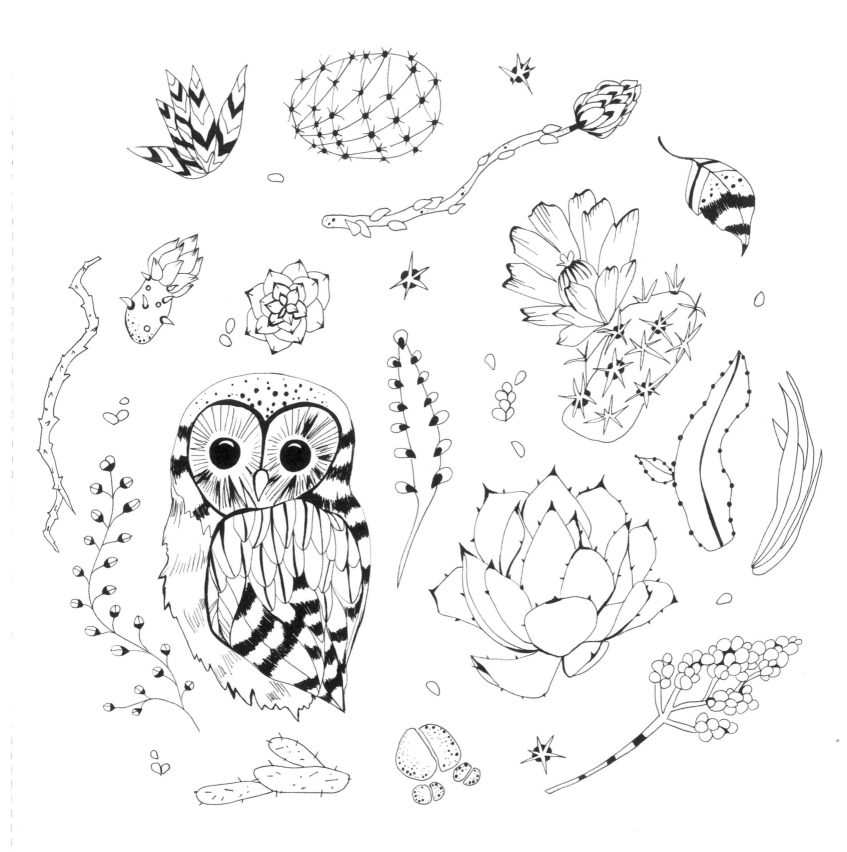

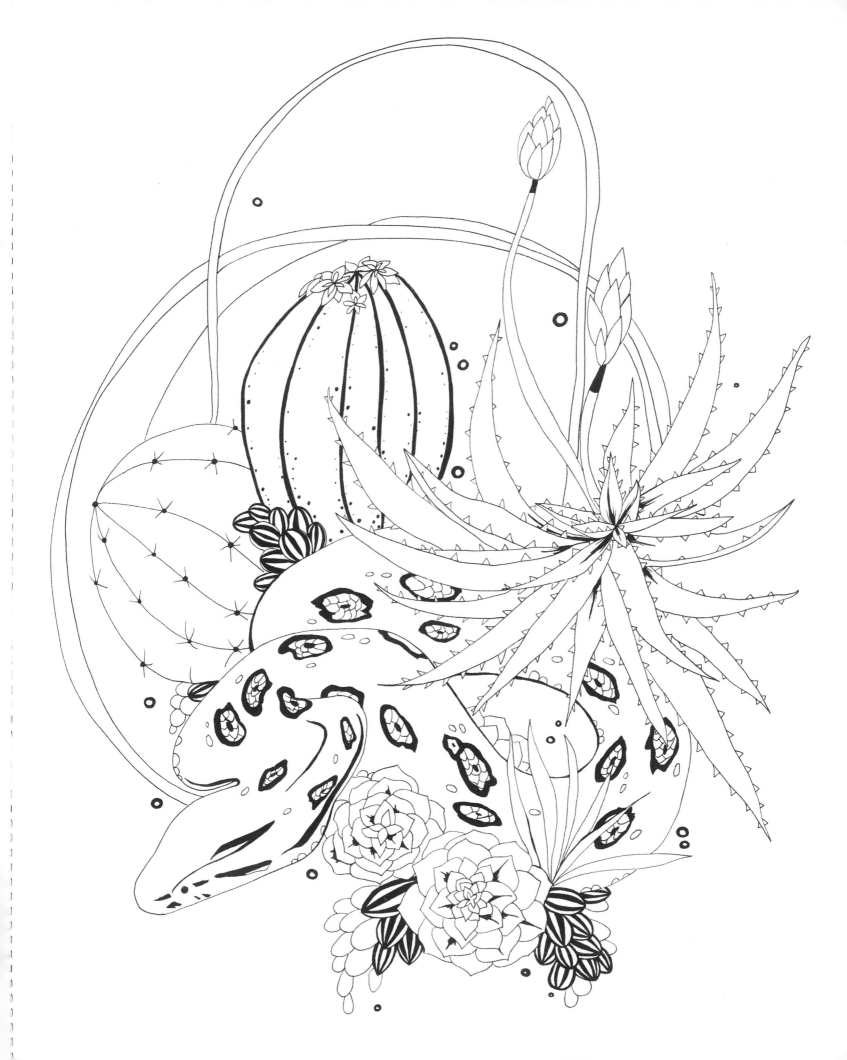

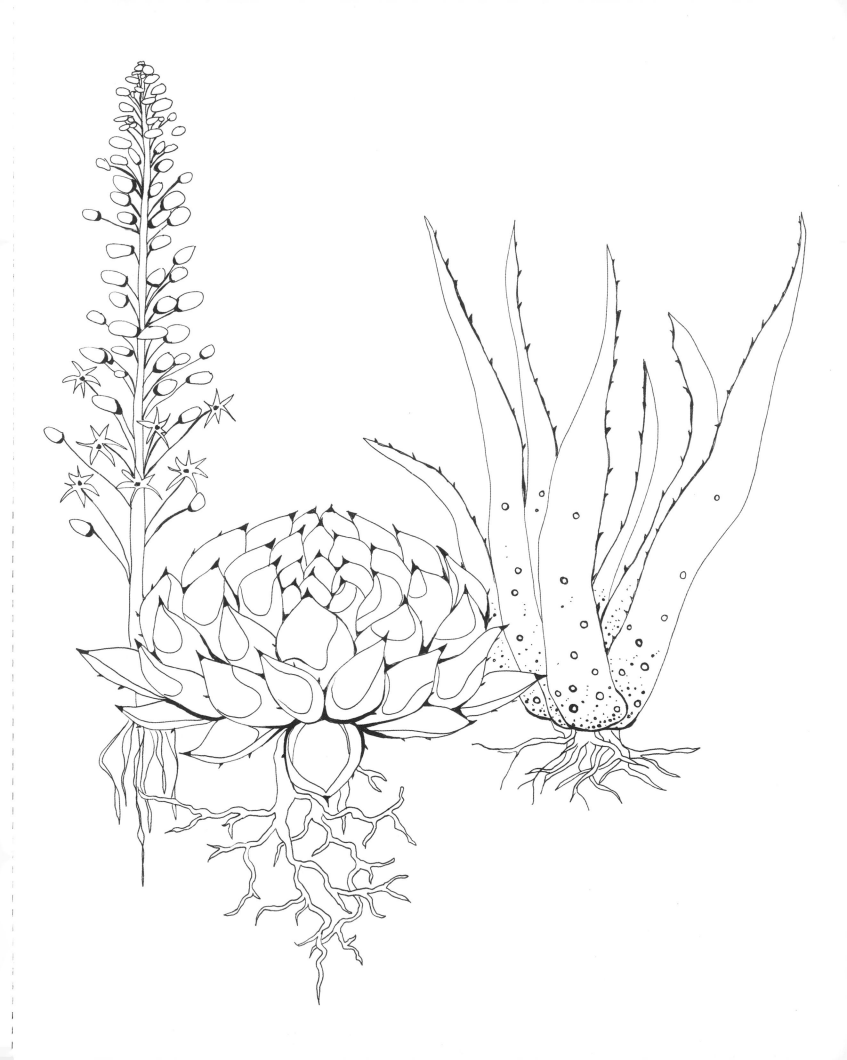

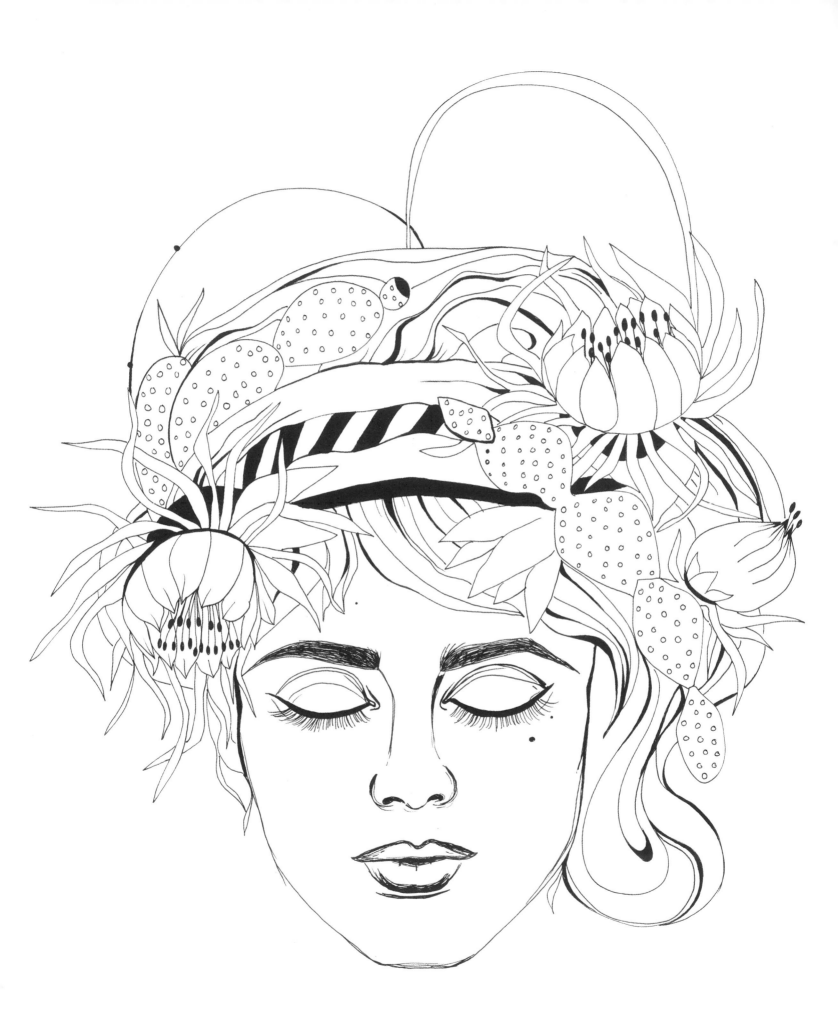

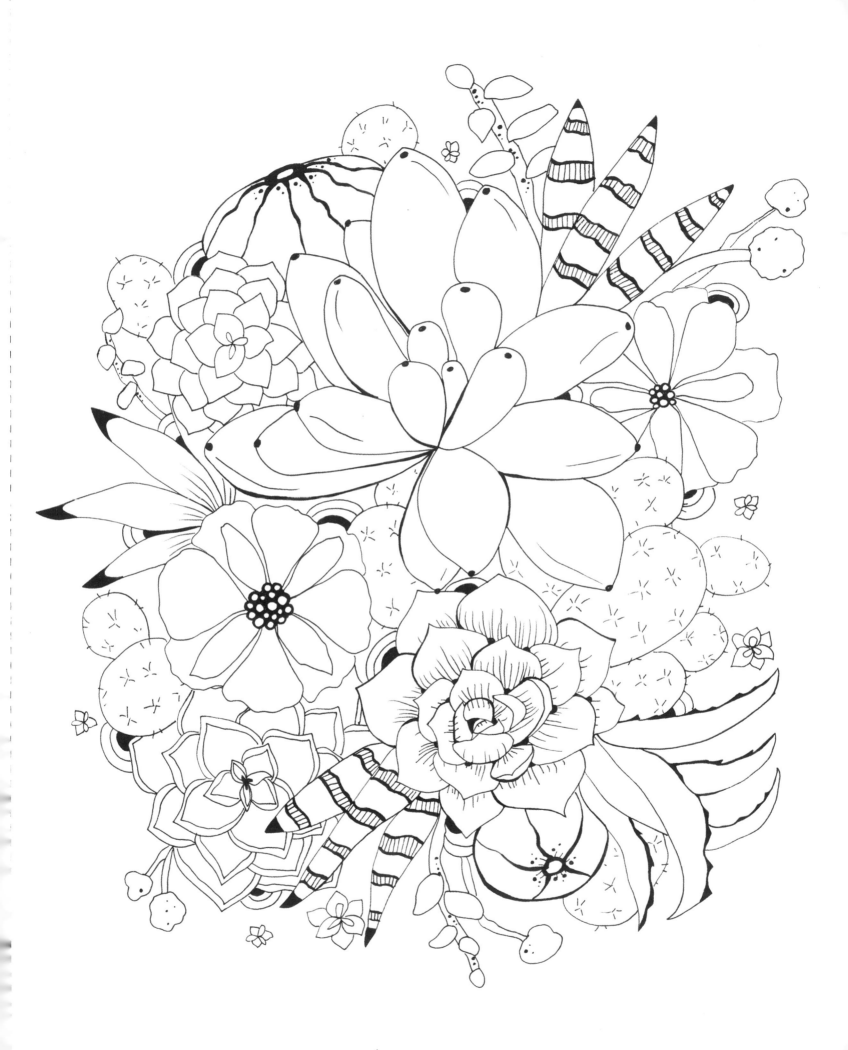

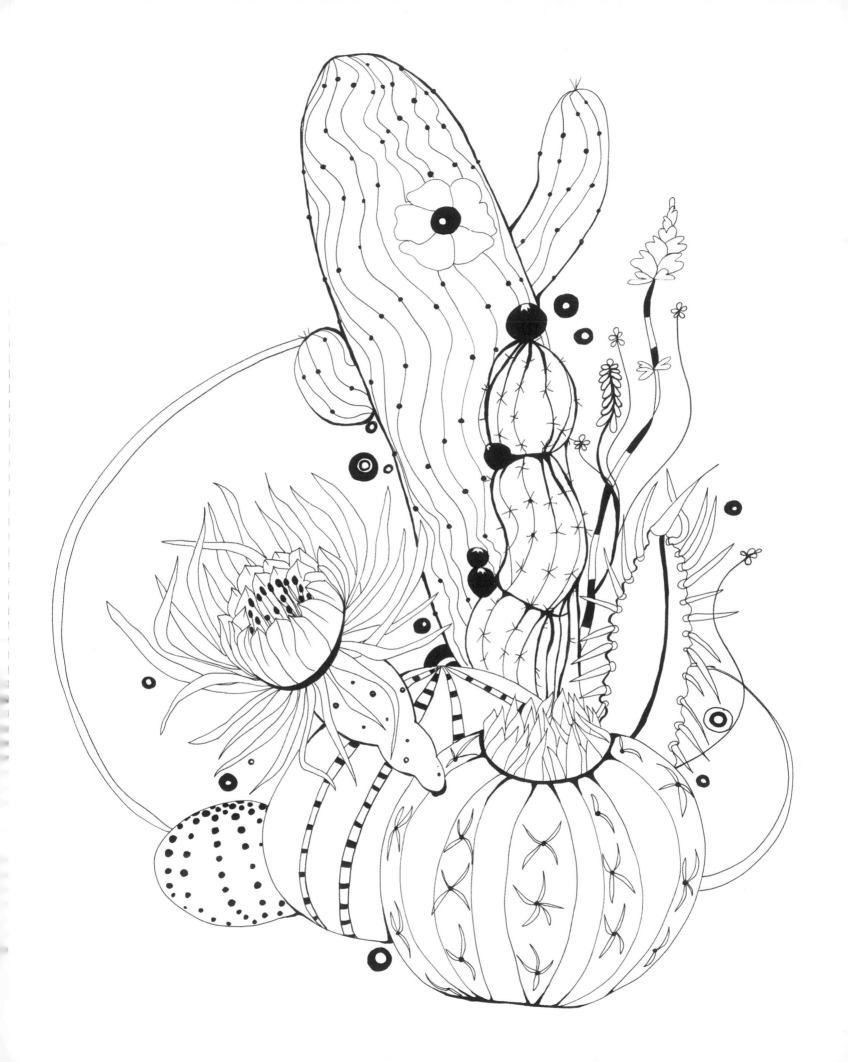

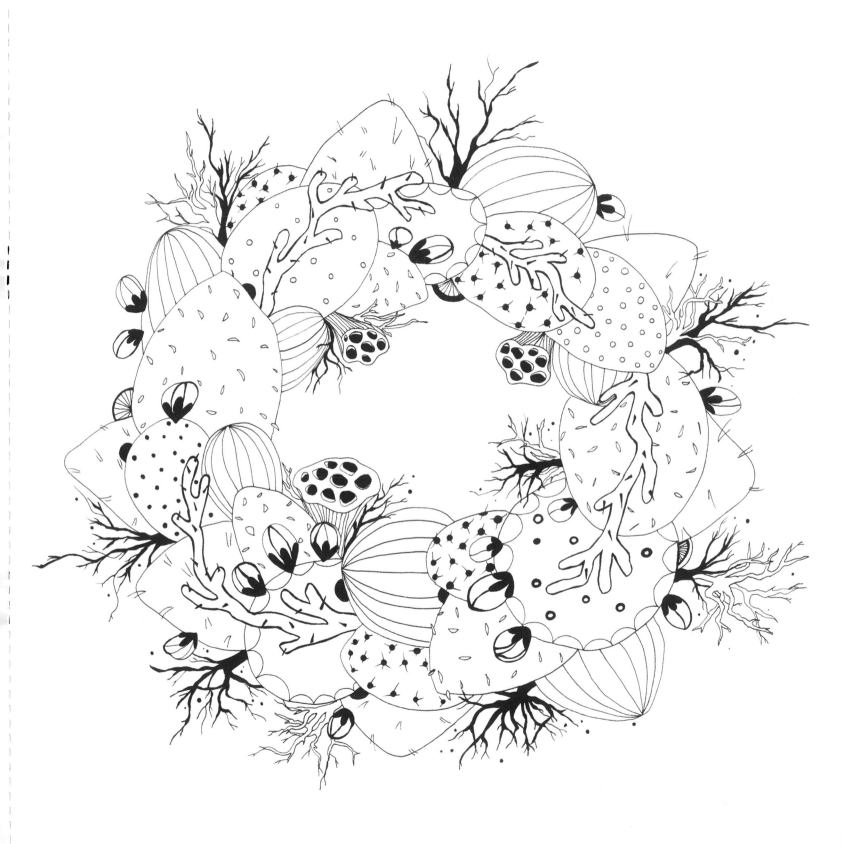

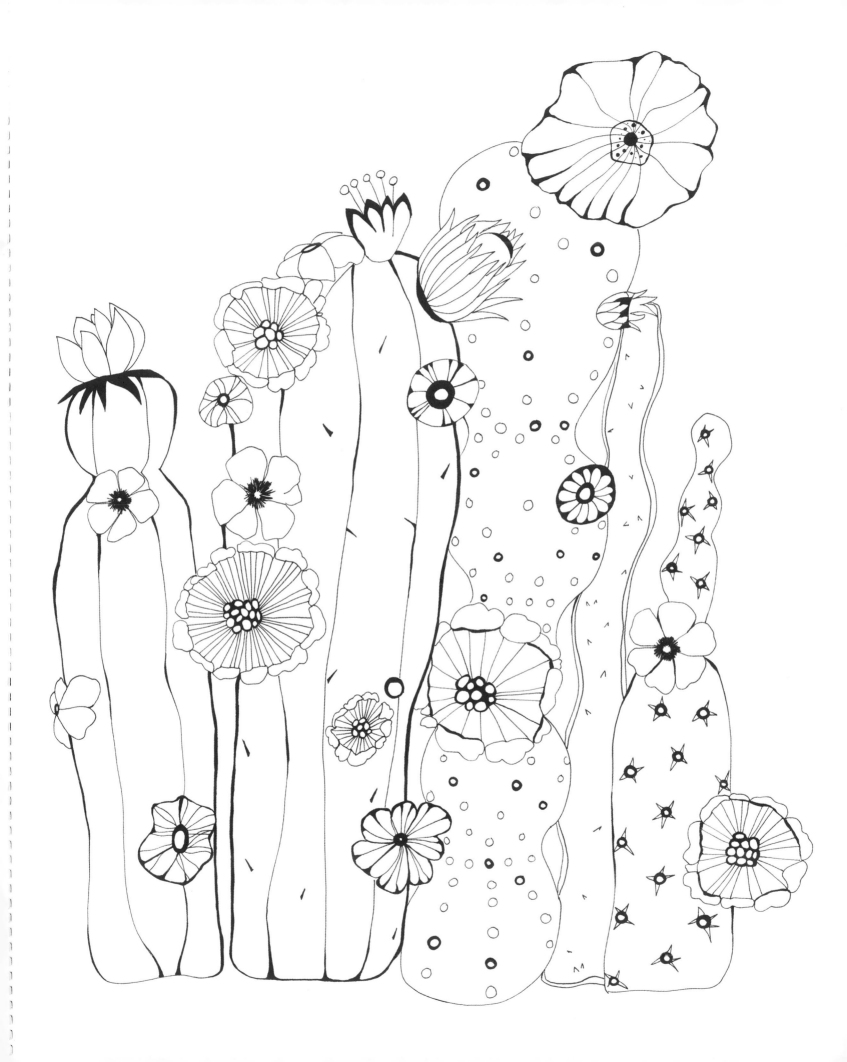

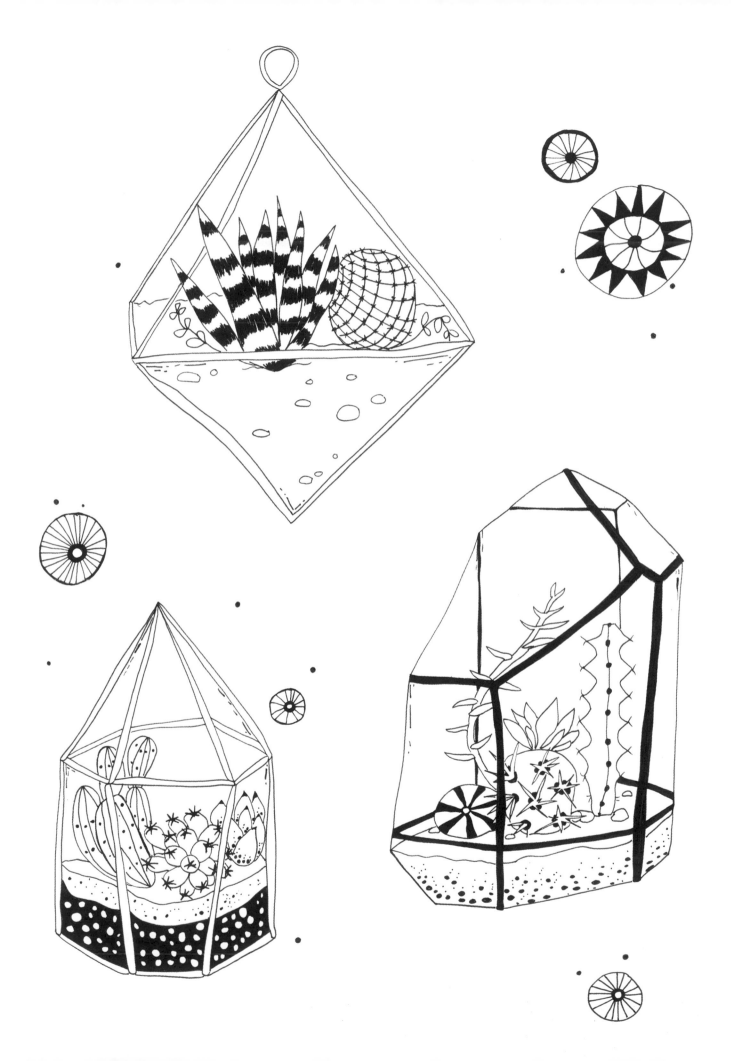

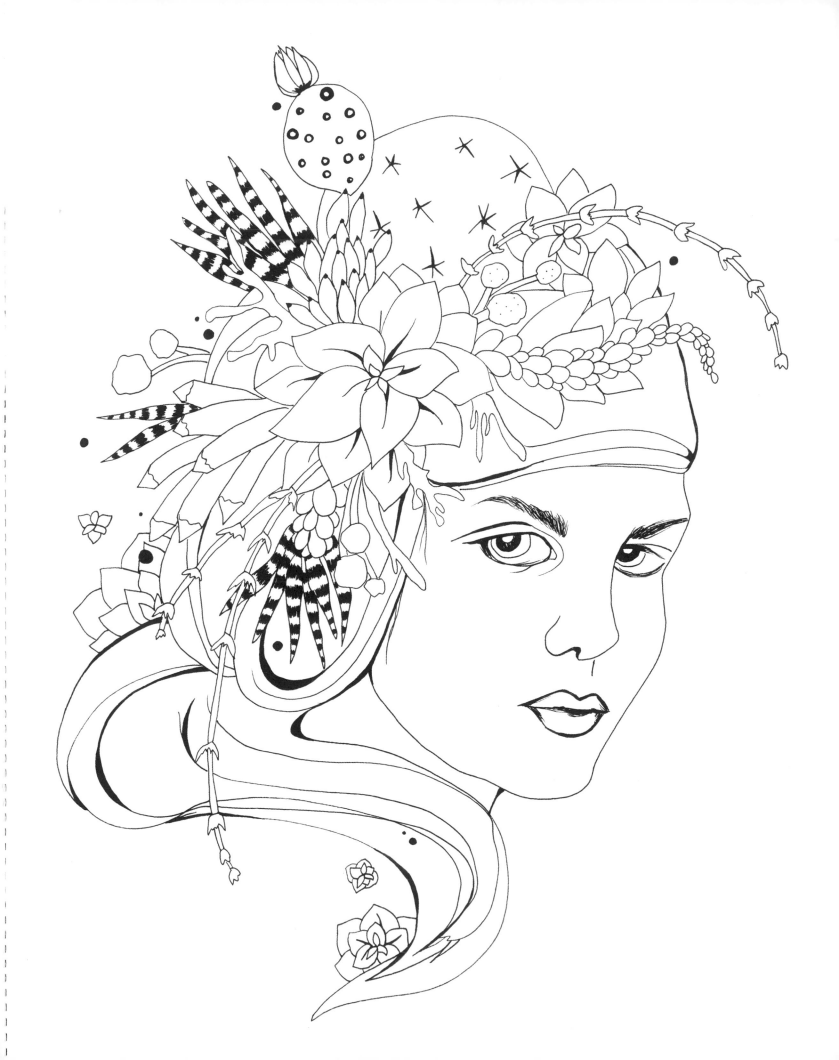

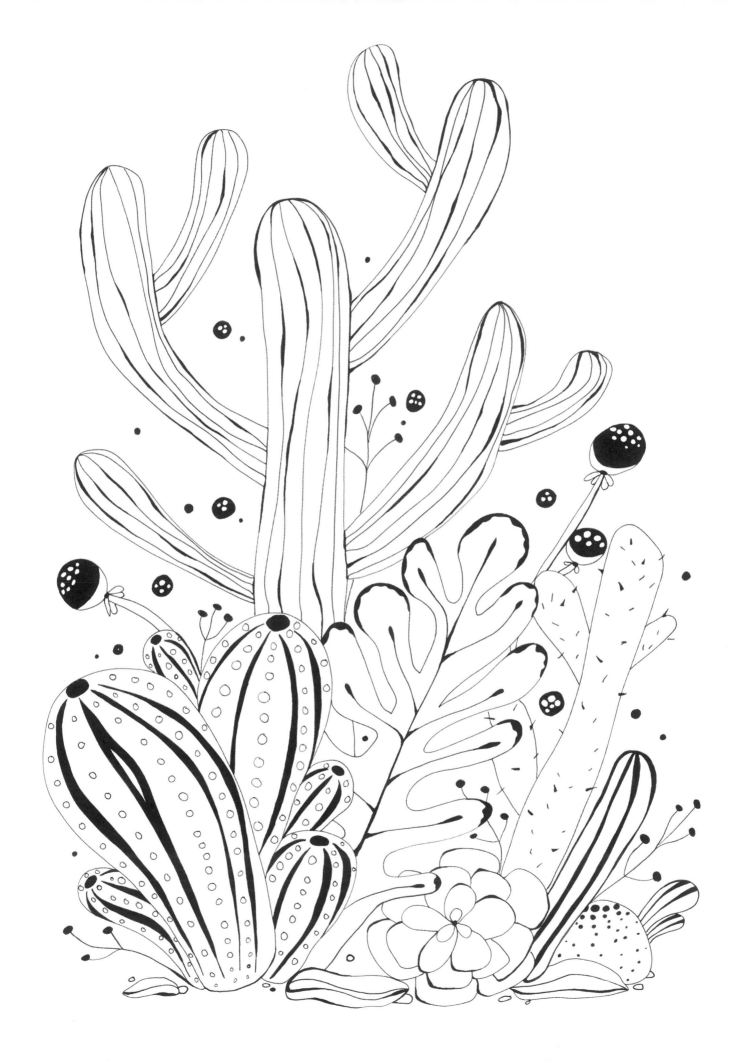

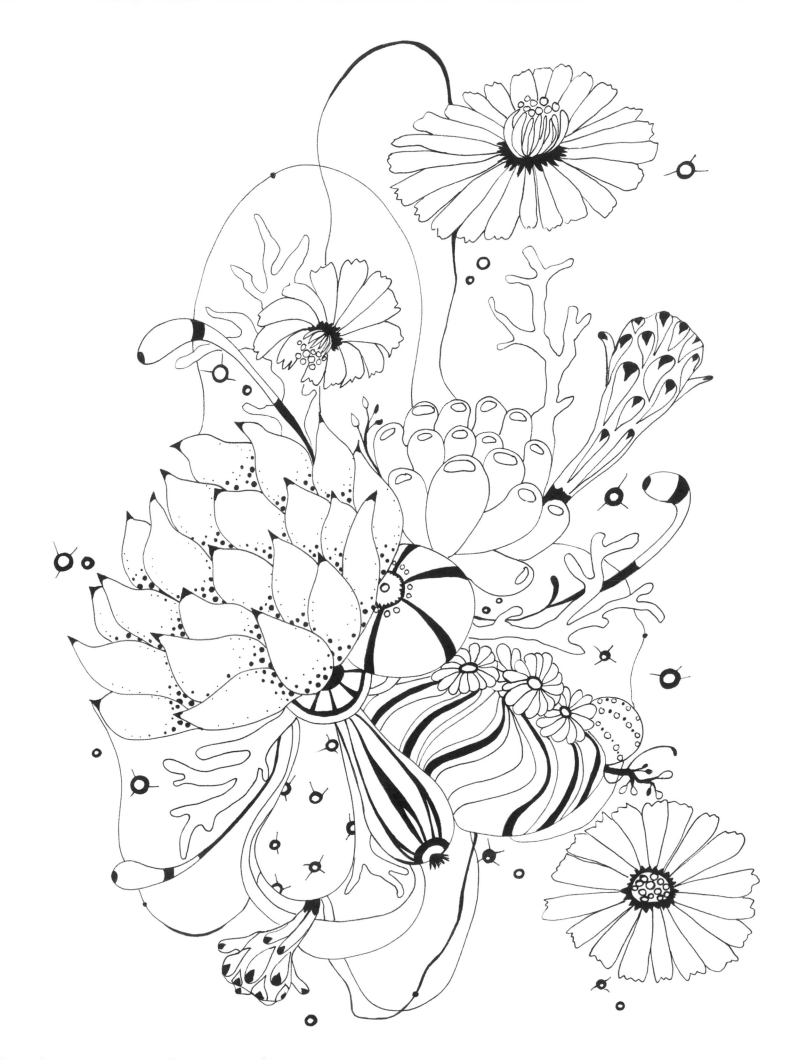

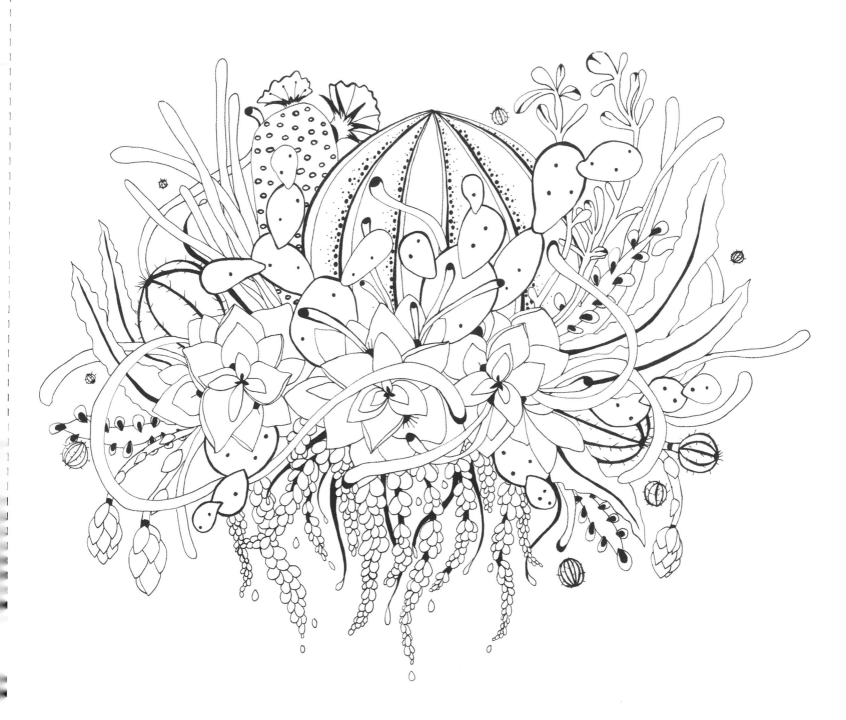

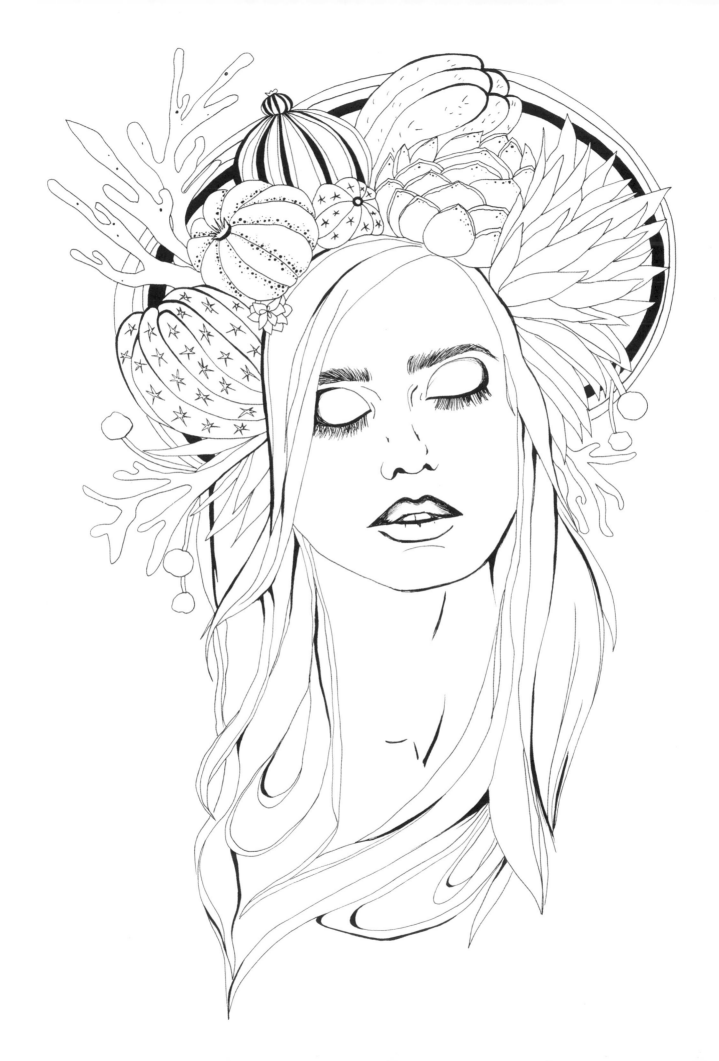

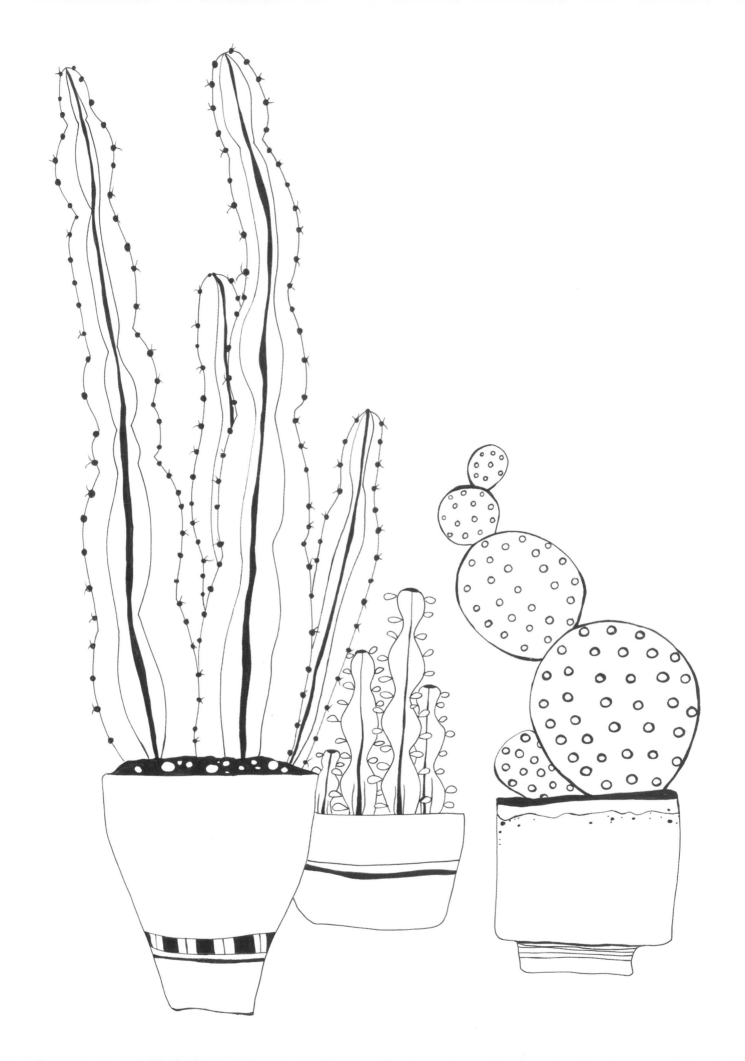

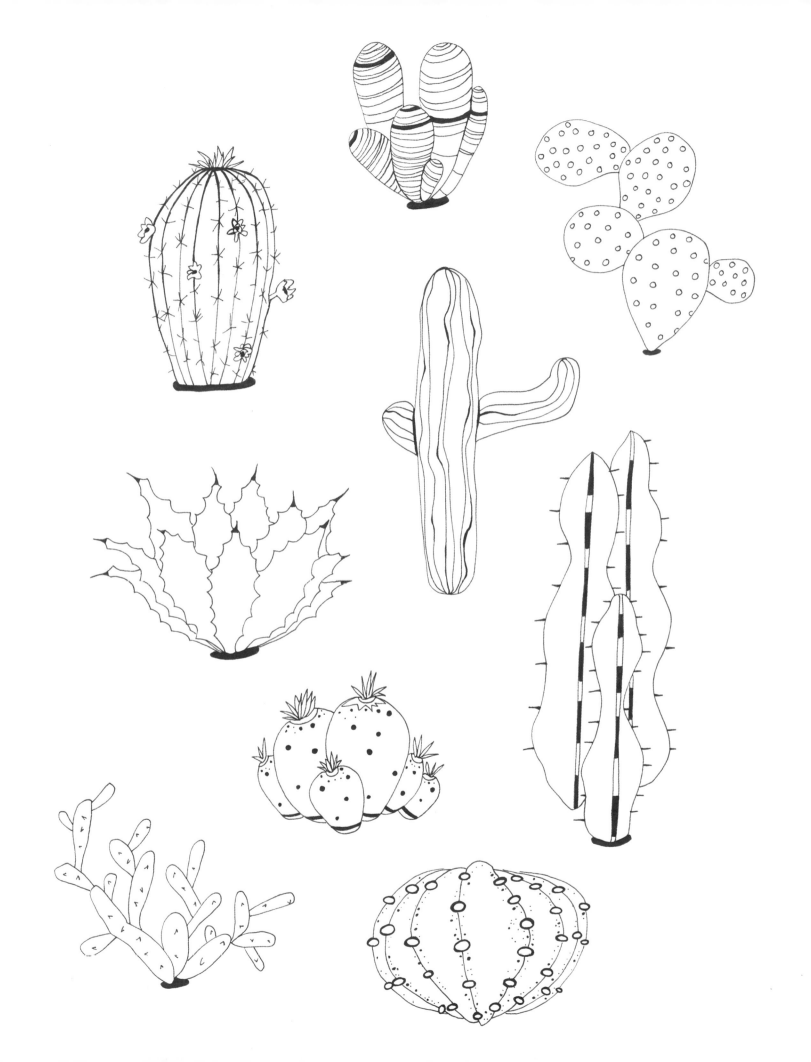

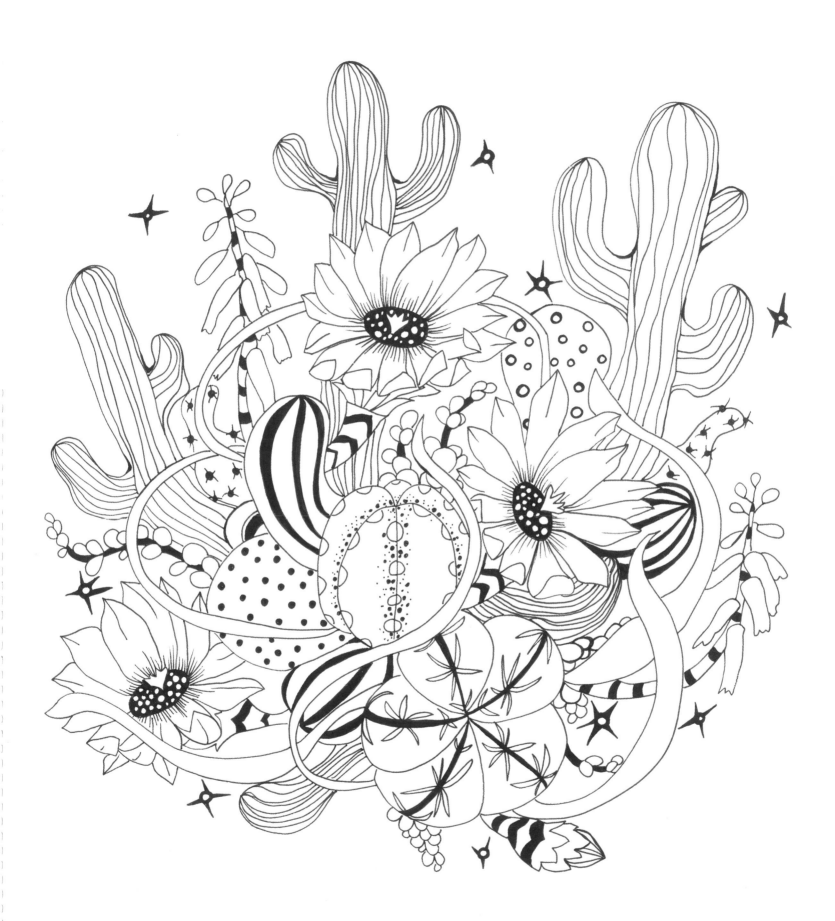

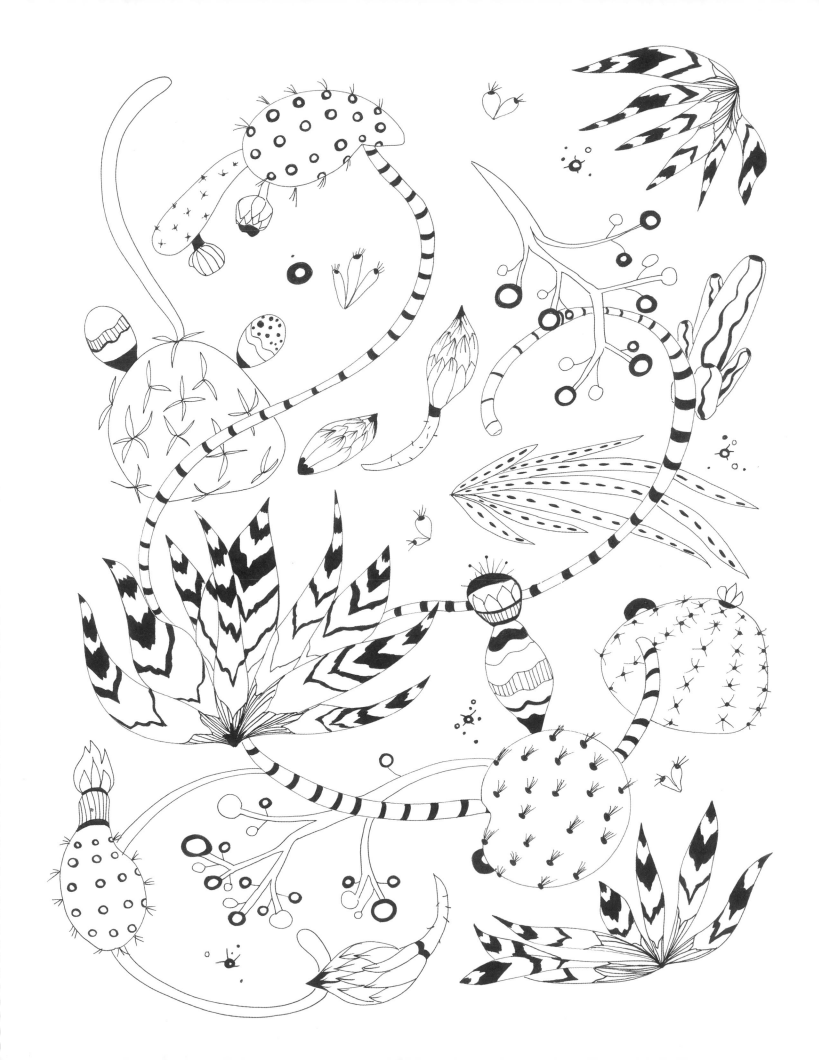

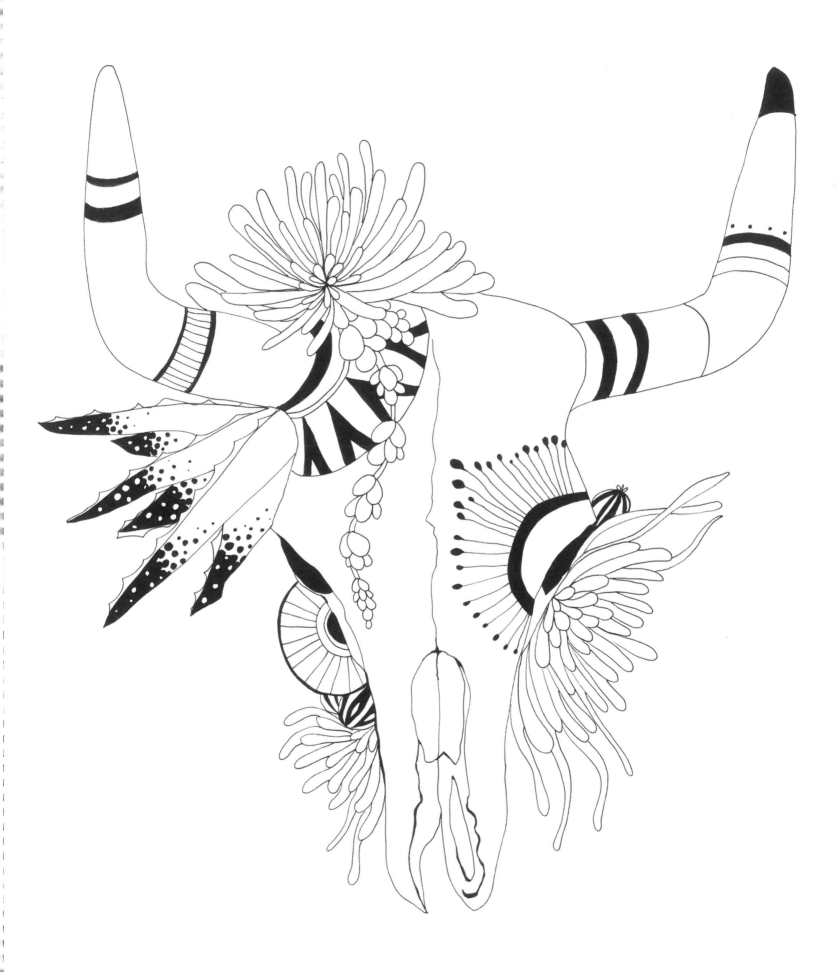

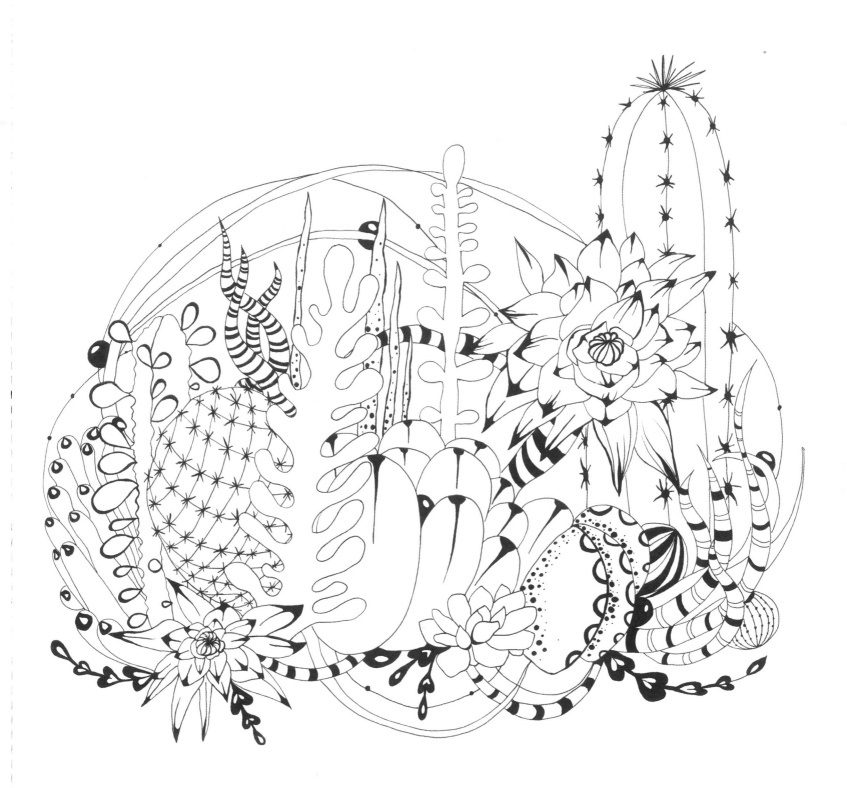

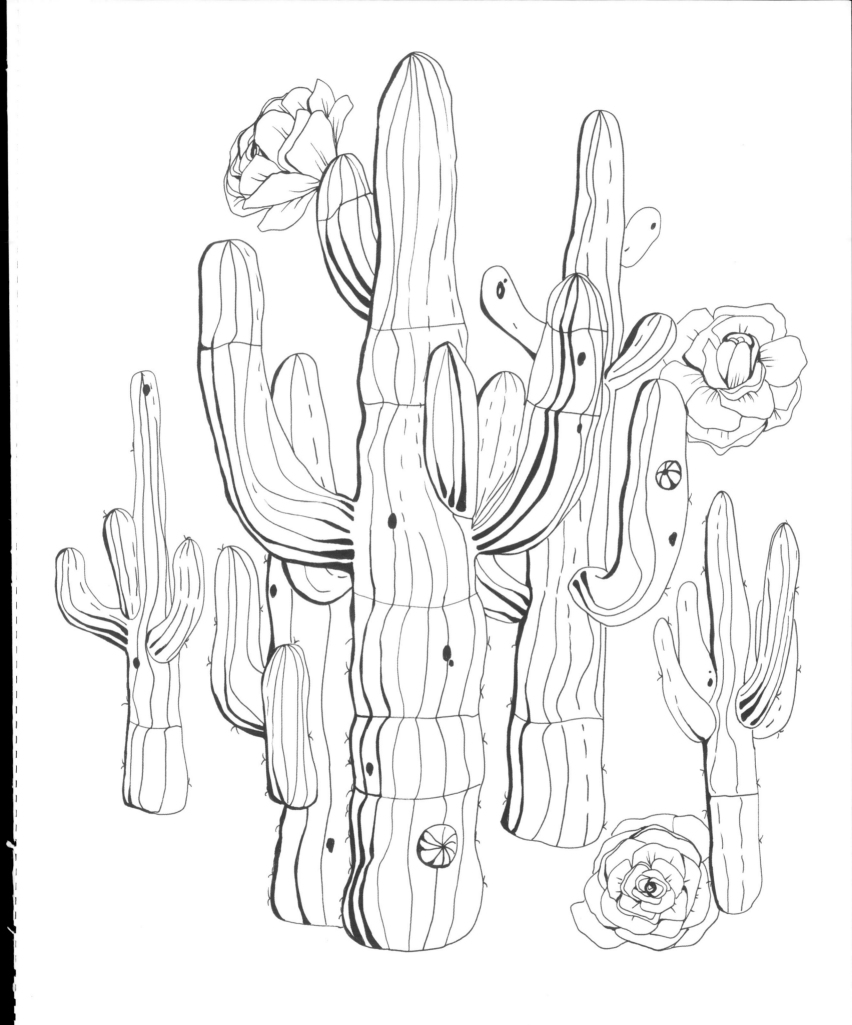

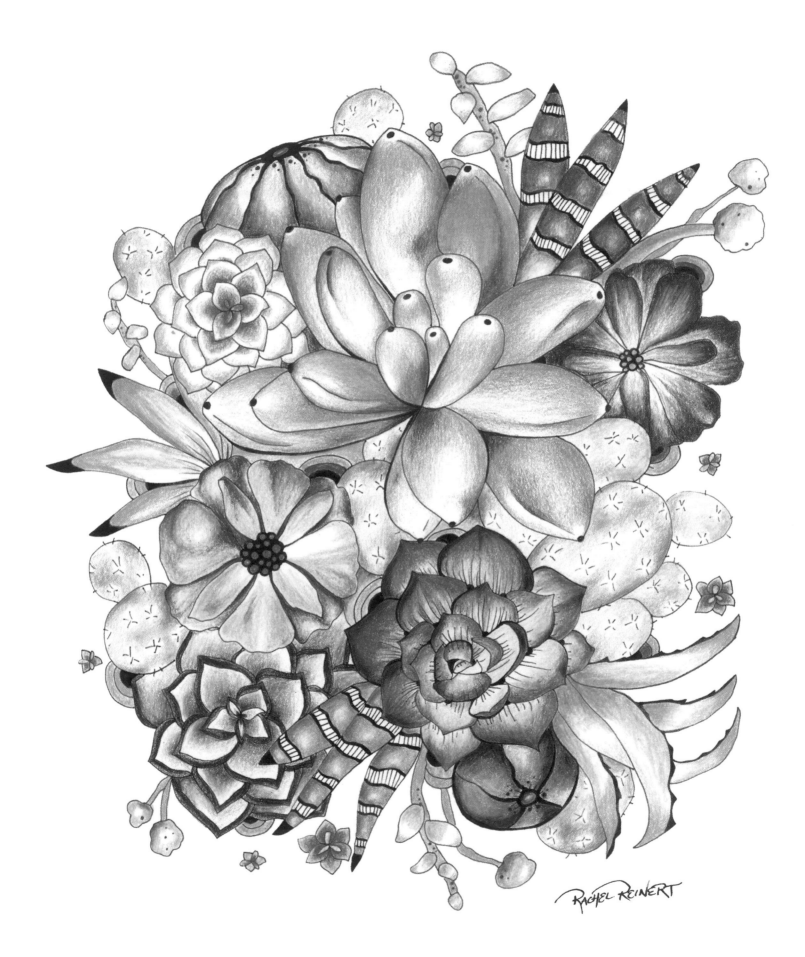

Rachel Reinert